PROBLEMS OF ART

BOOKS BY SUSANNE K. LANGER

PHILOSOPHY IN A NEW KEY
FEELING AND FORM
PROBLEMS OF ART

PROBLEMS

OF

ART

TEN PHILOSOPHICAL LECTURES

BY

SUSANNE K. LANGER

CHARLES SCRIBNER'S SONS NEW YORK

PRINTED IN THE UNITED STATES OF AMERICA

ISBN 0-684-15346-7

LIBRARY OF CONGRESS CATALOG CARD NUMBER 57-6068

TO MY LIFELONG SOCRATIC TEACHER

IN THE ARTS

HELEN SEWELL

CONTENTS

PREFACE

THE lectures here collected between two covers do not form a consecutive discourse; with exception of the three Matchette Lectures, grouped under the general title of "Pivotal Concepts in the Philosophy of Art," these were all separate addresses (to which is added one pubilshed essay, "Abstraction in Science and Abstraction in Art"). Each lecture was given to a different audience. For this reason, the basic ideas—the "pivotal concepts" on which my whole art theory turns—had to be expounded, or at least sketched, on almost every occasion. In a book such reiteration would, of course, be intolerable; hence the deletions and backward references in the text.

Although the various audiences—dancers, music students, college students, learned societies—usually represented some special interest or attitude to be met by the evening's talk, yet the lectures when put together prove to have a common theme, dictated by those central concepts that direct every special inquiry. Art has many problems, and every problem has many facets. But the basic issues—what is created, what is expressed, what is experienced—underlie them all, and all special solutions are developments of the crucial answers. The single lectures, therefore, may seem to be on as many single subjects, but they are really somewhat arbitrary small spotlights turned on the same great topic, the nature of Art.

"The Dynamic Image" was published in *Dance Observer* (Vol. XXIII, No. 6), July, 1956.

1

THE DYNAMIC IMAGE: SOME PHILOSOPHICAL REFLECTIONS ON DANCE

ONCE upon a time a student, paging through a college catalogue, asked me in evident bewilderment: "What is 'philosophy of art'? How in the world can art be philosophical?"

Art is not philosophical at all; philosophy and art are two different things. But there is nothing one cannot philosophize about—that is, there is nothing that does not offer some philosophical problems. Art, in particular, presents hosts of them. Artists do not generally moot such matters explicitly, though they often have fairly good working notions of a philosophical sort—notions that only have to be put into the right words to answer our questions, or at least to move them along toward their answers.

What, exactly, is a philosophical question?

A philosophical question is always a demand for the

meaning of what we are saying. This makes it different from a scientific question, which is a question of fact; in a question of fact, we take for granted that we know what we mean—that is, what we are talking about. If one asks: "How far from here is the sun?" the answer is a statement of fact, "About ninety million miles." We assume that we know what we mean by "the sun" and by "miles" and "being so-and-so far from here." Even if the answer is wrong—if it fails to state a fact, as it would if you answered "twenty thousand miles"—we still know what we are talking about. We take some measurements and find out which answer is true. But suppose one asks: "What is space?" "What is meant by 'here'?" "What is meant by 'the distance' from here to somewhere else?" The answer is not found by taking measurements or by making experiments or in any way discovering facts. The answer can only be found by thinking—reflecting on what we mean. This is sometimes simple; we analyze our meanings and define each word. But more often we find that we have no clear concepts at all, and the fuzzy ones we have conflict with each other so that as soon as we analyze them, i.e., make them clear, we find them contradictory, senseless, or fantastic. Then logical analysis does not help us; what we need then is the more difficult, but also more interesting part of philosophy, the part than can not be taught by any rule—logical construction. We have to figure out a meaning for our statements, a way to think about the things that interest us. Science is not possible unless we can attach some meaning to "distance" and "point" and "space" and "velocity," and other such familiar

but really quite slippery words. To establish those fundamental meanings is philosophical work; and the philosophy of modern science is one of the most brilliant intellectual works of our time.

The philosophy of art is not so well developed, but it is full of life and ferment just now. Both professional philosophers and intellectually gifted artists are asking questions about the meaning of "art," of "expression," of "artistic truth," "form," "reality," and dozens of other words that they hear and use, but find—to their surprise—they cannot define, because when they analyze what they mean it is not anything coherent and tenable.

The construction of a coherent theory—a set of connected ideas about some whole subject—begins with the solution of a central problem; that is, with the establishing of a key concept. There is no way of knowing, by any general rule, what constitutes a central problem; it is not always the most general or the most fundamental one you can raise. But the best sign that you have broached a central philosophical issue is that in solving it you raise new interesting questions. The concept you construct has *implications*, and by implication builds up further ideas, that illuminate other concepts of the whole subject, to answer other questions, sometimes before you even ask them. A key concept solves more problems than it was designed for.

In philosophy of art, one of the most interesting problems—one that proves to be really central—is the meaning of that much-used word, "creation." Why do we say an artist creates a work? He does not create oil pigments or canvas, or the structure of tonal vibrations,

or words of a language if he is a poet, or, in the case of a dancer, his body and its mobility. He finds all these things and uses them, as a cook uses eggs and flour and so forth to make a cake, or a manufacturer uses wool to make thread, and thread to make socks. It is only in a mood of humor or extravagance that we speak of the cake Mother "created." But when it comes to works of art, we earnestly call them creations. This raises the philosophical question: What do we mean by that word? What is created?

If you pursue this issue, it grows into a complex of closely related questions: what is created in art, what for, and how? The answers involve just about all the key concepts for a coherent philosophy of art: such concepts as *apparition,* or the image, *expressiveness, feeling, motif, transformation.* There are others, but they are all interrelated.

It is impossible to talk, in one lecture, about all the arts, and not end with a confusion of principles and illustrations. Since we are particularly concerned, just now, with the dance, let us narrow our discussion and center it about this art. Our first question, then, becomes: What do dancers create?

Obviously, a dance. As I pointed out before, they do not create the materials of the dance—neither their own bodies, nor the cloth that drapes them, nor the floor, nor any of the ambient space, light, musical tone, the forces of gravity, nor any other physical provisions; all these things they *use,* to create something over and above what is physically there: the dance.

What, then, is the dance?

4

The dance is an appearance; if you like, an apparition. It springs from what the dancers do, yet it is something else. In watching a dance, you do not see what is physically before you—people running around or twisting their bodies; what you see is a display of interacting forces, by which the dance seems to be lifted, driven, drawn, closed, or attenuated, whether it be solo or choric, whirling like the end of a dervish dance, or slow, centered, and single in its motion. One human body may put the whole play of mysterious powers before you. But these powers, these forces that seem to operate in the dance, are not the physical forces of the dancer's muscles, which actually cause the movements taking place. The forces we seem to perceive most directly and convincingly are created for our perception; and they exist only for it.

Anything that exists only for perception, and plays no ordinary, passive part in nature as common objects do, is a virtual entity. It is not unreal; where it confronts you, you really perceive it, you don't dream or imagine that you do. The image in a mirror is a virtual image. A rainbow is a virtual object. It seems to stand on the earth or in the clouds, but it really "stands" nowhere; it is only visible, not tangible. Yet it is a real rainbow, produced by moisture and light for any normal eye looking at it from the right place. We don't just dream that we see it. If, however, we believe it to have the ordinary properties of a physical thing, we are mistaken; it is an appearance, a virtual object, a sun-created image.

What dancers create is a dance; and a dance is an apparition of active powers, a *dynamic image*. Everything

5

a dancer actually does serves to create what we really see; but what we really see is a virtual entity. The physical realities are given: place, gravity, body, muscular strength, muscular control, and secondary assets such as light, sound, or things (usable objects, so-called "properties"). All these are actual. But in the dance, they disappear; the more perfect the dance, the less we see its actualities. What we see, hear, and feel are the virtual realities, the moving forces of the dance, the apparent centers of power and their emanations, their conflicts and resolutions, lift and decline, their rhythmic life. These are the elements of the created apparition, and are themselves not physically given, but artistically created.

Here we have, then, the answer to our first question: what do dancers create? The dynamic image, which is the dance.

This answer leads naturally to the second question: for what is this image created?

Again, there is an obvious answer: for our enjoyment. But what makes us enjoy it as intensely as we do? We do not enjoy every virtual image, just because it is one. A mirage in the desert is intriguing chiefly because it is rare. A mirror image, being common, is not an object of wonder, and in itself, just as an image, does not thrill us. But the dynamic image created in dancing has a different character. It is more than a perceivable entity; this apparition, given to the eye, or to the ear and eye, and through them to our whole responsive sensibility, strikes us as something charged with feeling. Yet this feeling is not necessarily what any or all of the dancers

6

feel. It belongs to the dance itself. A dance, like any other work of art, is a perceptible form that expresses the nature of human feeling—the rhythms and connections, crises and breaks, the complexity and richness of what is sometimes called man's "inner life," the stream of direct experience, life as it feels to the living. Dancing is not a symptom of how the dancer happens to feel; for the dancer's own feelings could not be prescribed or predicted and exhibited upon request. Our own feelings simply occur, and most people do not care to have us express them by sighs or squeals or gesticulation. If that were what dancers really did, there would not be many balletomaniacs to watch them.

What is expressed in a dance is an idea; an idea of the way feelings, emotions, and all other subjective experiences come and go—their rise and growth, their intricate synthesis that gives our inner life unity and personal identity. What we call a person's "inner life" is the inside story of his own history; the way living in the world feels to him. This kind of experience is usually but vaguely known, because most of its components are nameless, and no matter how keen our experience may be, it is hard to form an idea of anything that has no name. It has no handle for the mind. This has led many learned people to believe that feeling is a formless affair, that it has causes which may be determined, and effects that have to be dealt with, but that in itself it is irrational—a disturbance in the organism, with no structure of its own.

Yet subjective existence has a structure; it is not only met from moment to moment, but can be conceptually

7

known, reflected on, imagined and symbolically expressed in detail and to a great depth. Only it is not our usual medium, discourse—communication by language —that serves to express what we know of the life of feeling. There are logical reasons why language fails to meet this purpose, reasons I will not try to explain now. The important fact is that what language does not readily do—present the nature and patterns of sensitive and emotional life—is done by works of art. Such works are expressive forms, and what they express is the nature of human feeling.

So we have played our second gambit, answering the second question: What is the work of art for—the dance, the virtual dynamic image? To express its creator's ideas of immediate, felt, emotive life. To set forth directly what feeling is like. A work of art is a composition of tensions and resolutions, balance and unbalance, rhythmic coherence, a precarious yet continuous unity. Life is a natural process of such tensions, balances, rhythms; it is these that we feel, in quietness or emotion, as the pulse of our own living. In the work of art they are expressed, symbolically shown, each aspect of feeling developed as one develops an idea, fitted together for clearest presentation. A dance is not a symptom of a dancer's feeling, but an expression of its composer's knowledge of many feelings.

The third problem on the docket—how is a dance created?—is so great that one has to break it down into several questions. Some of these are practical questions of technique—how to produce this or that effect. They concern many of you but not me, except in so far as

solutions of artistic problems always intrigue me. The philosophical question that I would peel out of its many wrappings is: What does it mean to express one's idea of some inward or "subjective" process?

It means to make an outward image of this inward process, for oneself and others to see; that is, to give the subjective events an objective symbol. Every work of art is such an image, whether it be a dance, a statue, a picture, a piece of music, or a work of poetry. It is an outward showing of inward nature, an objective presentation of subjective reality; and the reason that it can symbolize things of the inner life is that it has the same kinds of relations and elements. This is not true of the material structure; the physical materials of a dance do not have any direct similarity to the structure of emotive life; it is the created image that has elements and patterns like the life of feeling. But this image, though it is a created apparition, a pure appearance, is objective; it seems to be charged with feeling because its form expresses the very nature of feeling. Therefore, it is an *objectification* of subjective life, and so is every other work of art.

If works of art are all alike in this fundamental respect, why have we several great domains of art, such as painting and music, poetry and dance? Something makes them so distinct from each other that people with superb talent for one may have none for another. A sensible person would not go to Picasso to learn dancing or to Hindemith to be taught painting. How does dancing, for instance, differ from music or architecture or drama? It has relations with all of them. Yet it is none of them.

9

What makes the distinction among the several great orders of art is another of those problems that arise in their turn, uninvited, once you start from a central question; and the fact that the question of *what is created* leads from one issue to another in this natural and systematic way makes me think it really is central. The distinction between dancing and all of the other great arts —and of those from each other—lies in the stuff of which the virtual image, the expressive form, is made. We cannot go into any discussion of other kinds, but only reflect a little further on our original query: What do dancers create? What is a dance?

As I said before (so long before that you have probably forgotten), what we see when we watch a dance is a display of interacting forces; not physical forces, like the weight that tips a scale or the push that topples a column of books, but purely apparent forces that seem to move the dance itself. Two people in a *pas de deux* seem to magnetize each other; a group appears to be animated by one single spirit, one Power. The stuff of the dance, the apparition itself, consists of such nonphysical forces, drawing and driving, holding and shaping its life. The actual, physical forces that underlie it disappear. As soon as the beholder sees gymnastics and arrangements, the work of art breaks, the creation fails.

As painting is made purely of spatial volumes—not actual space-filling things but virtual volumes, created solely for the eye—and music is made of passage, movements of time, created by tone—so dance creates a world of powers, made visible by the unbroken fabric of ges-

ture. That is what makes dance a different art from all the others. But as Space, Events, Time, and Powers are all interrelated in reality, so all the arts are linked by intricate relations, different among different ones. That is a big subject.

Another problem which naturally presents itself here is the meaning of *dance gesture*; but we shall have to skip it. We have had enough pursuit of meanings, and I know from experience that if you don't make an end of it, there is no end. But in dropping the curtain on this peep-show of philosophy, I would like to call your attention to one of those unexpected explanations of puzzling facts that sometimes arise from philosophical reflection.

Curt Sachs, who is an eminent historian of music and dance, remarks in his *World History of Dance* that, strange as it may seem, the evolution of the dance as a high art belongs to pre-history. At the dawn of civilization, dance had already reached a degree of perfection that no other art or science could match. Societies limited to savage living, primitive sculpture, primitive architecture, and as yet no poetry, quite commonly present the astonished ethnologist with a highly developed tradition of difficult, beautiful dancing. Their music apart from the dance is nothing at all; in the dance it is elaborate. Their worship is dance. They are tribes of dancers.

If you think of the dance as an apparition of interactive Powers, this strange fact loses its strangeness. Every art image is a purified and simplified aspect of the outer world, composed by the laws of the inner world to express its nature. As one objective aspect of the world after another comes to people's notice, the arts arise.

Each makes its own image of outward reality to objectify inward reality, subjective life, feeling.

Primitive men live in a world of demonic Powers. Subhuman or superhuman, gods or spooks or impersonal magic forces, good or bad luck that dwells in things like an electric charge, are the most impressive realities of the savage's world. The drive to artistic creation, which seems to be deeply primitive in all human beings, first begets its forms in the image of these all-surrounding Powers. The magic circle around the altar or the totem pole, the holy space inside the Kiwa or the temple, is the natural dance floor. There is nothing unreasonable about that. In a world perceived as a realm of mystic Powers, the first created image is the dynamic image; the first objectification of human nature, the first true art, is Dance.

2

EXPRESSIVENESS

WHEN we talk about "Art" with a capital "A"—that is, about any or all of the arts: painting, sculpture, architecture, the potter's and goldsmith's and other designers' arts, music, dance, poetry, and prose fiction, drama and film—it is a constant temptation to say things about "Art" in this general sense that are true only in one special domain, or to assume that what holds for one art must hold for another. For instance, the fact that music is made for performance, for presentation to the ear, and is simply not the same thing when it is given only to the tonal imagination of a reader silently perusing the score, has made some aestheticians pass straight to the conclusion that literature, too, must be physically heard to be fully experienced, because words are originally spoken, not written; an obvious parallel, but a careless and, I think, invalid one. It is dangerous to set up principles by analogy, and generalize from a single consideration.

But it is natural, and safe enough, to ask analogous

questions: "What is the function of sound in music? What is the function of sound in poetry? What is the function of sound in prose composition? What is the function of sound in drama?" The answers may be quite heterogeneous; and that is itself an important fact, a guide to something more than a simple and sweeping theory. Such findings guide us to exact relations and abstract, variously exemplified basic principles.

At present, however, we are dealing with principles that have proven to be the same in all the arts, when each kind of art—plastic, musical, balletic, poetic, and each major mode, such as literary and dramatic writing, or painting, sculpturing, building plastic shapes—has been studied in its own terms. Such candid study is more rewarding than the usual passionate declaration that all the arts are alike, only their materials differ, their principles are all the same, their techniques all analogous, etc. That is not only unsafe, but untrue. It is in pursuing the differences among them that one arrives, finally, at a point where no more differences appear; then one has found, not postulated, their unity. At that deep level there is only one concept exemplified in all the different arts, and that is the concept of Art.

The principles that obtain wholly and fundamentally in every kind of art are few, but decisive; they determine what is art, and what is not. Expressiveness, in one definite and appropriate sense, is the same in all art works of any kind. What is created is not the same in any two distinct arts—this is, in fact, what makes them distinct— but the principle of creation is the same. And "living form" means the same in all of them.

A work of art is an expressive form created for our perception through sense or imagination, and what it expresses is human feeling. The word "feeling" must be taken here in its broadest sense, meaning *everything that can be felt*, from physical sensation, pain and comfort, excitement and repose, to the most complex emotions, intellectual tensions, or the steady feeling-tones of a conscious human life. In stating what a work of art is, I have just used the words "form," "expressive," and "created"; these are key words. One at a time, they will keep us engaged.

Let us consider first what is meant, in this context, by a *form*. The word has many meanings, all equally legitimate for various purposes; even in connection with art it has several. It may, for instance—and often does—denote the familiar, characteristic structures known as the sonnet form, the sestina, or the ballad form in poetry, the sonata form, the madrigal, or the symphony in music, the contredance or the classical ballet in choreography, and so on. This is not what I mean; or rather, it is only a very small part of what I mean. There is another sense in which artists speak of "form" when they say, for instance, "form follows function," or declare that the one quality shared by all good works of art is "significant form," or entitle a book *The Problem of Form in Painting and Sculpture*, or *The Life of Forms in Art*, or *Search for Form*. They are using "form" in a wider sense, which on the one hand is close to the commonest, popular meaning, namely just the *shape* of a thing, and on the other hand to the quite unpopular meaning it has in science and philosophy, where it designates something

more abstract; "form" in its most abstract sense means structure, articulation, a whole resulting from the relation of mutually dependent factors, or more precisely, the way that whole is put together.

The abstract sense, which is sometimes called "logical form," is involved in the notion of expression, at least the kind of expression that characterizes art. That is why artists, when they speak of achieving "form," use the word with something of an abstract connotation, even when they are talking about a visible and tangible art object in which that form is embodied.

The more recondite concept of form is derived, of course, from the naive one, that is, material shape. Perhaps the easiest way to grasp the idea of "logical form" is to trace its derivation.

Let us consider the most obvious sort of form, the shape of an object, say a lampshade. In any department store you will find a wide choice of lampshades, mostly monstrosities, and what is monstrous is usually their shape. You select the least offensive one, maybe even a good one, but realize that the color, say violet, will not fit into your room; so you look about for another shade of the same shape but a different color, perhaps green. In recognizing this same shape in another object, possibly of another material as well as another color, you have quite naturally and easily abstracted the concept of this shape from your actual impression of the first lampshade. Presently it may occur to you that this shade is too big for your lamp; you ask whether they have *this same shade* (meaning another one of this shape) in a smaller size. The clerk understands you.

But what is *the same* in the big violet shade and the little green one? Nothing but the interrelations among their respective various dimensions. They are not "the same" even in their spatial properties, for none of their actual measures are alike; but their shapes are congruent. Their respective spatial factors are put together in the same way, so they exemplify the same form.

It is really astounding what complicated abstractions we make in our ordinary dealing with forms—that is to say, through what twists and transformations we recognize the same logical form. Consider the similarity of your two hands. Put one on the table, palm down, superimpose the other, palm down, as you may have superimposed cut-out geometric shapes in school—they are not alike at all. But their shapes are *exact opposites*. Their respective shapes fit the same description, provided that the description is modified by a principle of application whereby the measures are read one way for one hand and the other way for the other—like a timetable in which the list of stations is marked: "Eastbound, read down; Westbound, read up."

As the two hands exemplify the same form with a principle of reversal understood, so the list of stations describes two ways of moving, indicated by the advice to "read down" for one and "read up" for the other. We can all abstract the common element in these two respective trips, which is called the *route*. With a return ticket we may return only by the same route. The same principle relates a mold to the form of the thing that is cast in it, and establishes their formal correspondence, or common logical form.

17

So far we have considered only objects—lampshades, hands, or regions of the earth—as having forms. These have fixed shapes; their parts remain in fairly stable relations to each other. But there are also substances that have no definite shapes, such as gases, mist, and water, which take the shape of any bounded space that contains them. The interesting thing about such amorphous fluids is that when they are put into violent motion they do exhibit visible forms, not bounded by any container. Think of the momentary efflorescence of a bursting rocket, the mushroom cloud of an atomic bomb, the funnel of water or dust screwing upward in a whirl-wind. The instant the motion stops, or even slows beyond a certain degree, those shapes collapse and the apparent "thing" disappears. They are not shapes of things at all, but forms of motions, or dynamic forms.

Some dynamic forms, however, have more permanent manifestations, because the stuff that moves and makes them visible is constantly replenished. A waterfall seems to hang from the cliff, waving streamers of foam. Actually, of course, nothing stays there in mid-air; the water is always passing; but there is more and more water taking the same paths, so we have a lasting shape made and maintained by its passage—a permanent dynamic form. A quiet river, too, has dynamic form; if it stopped flowing it would either go dry or become a lake. Some twenty-five hundred years ago, Heracleitos was struck by the fact that you cannot step twice into the same river at the same place—at least, if the river means the water, not its dynamic form, the flow.

When a river ceases to flow because the water is

deflected or dried up, there remains the river bed, some-times cut deeply in solid stone. That bed is shaped by the flow, and records as graven lines the currents that have ceased to exist. Its shape is static, but it *expresses* the dynamic form of the river. Again, we have two con-gruent forms, like a cast and its mold, but this time the congruence is more remarkable because it holds between a dynamic form and a static one. That relation is im-portant; we shall be dealing with it again when we come to consider the meaning of "living form" in art.

The congruence of two given perceptible forms is not always evident upon simple inspection. The common *logical* form they both exhibit may become apparent only when you know the principle whereby to relate them, as you compare the shapes of your hands not by direct correspondence, but by correspondence of op-posite parts. Where the two exemplifications of the single logical form are unlike in most other respects one needs a rule for matching up the relevant factors of one with the relevant factors of the other; that is to say, a *rule of translation*, whereby one instance of the logical form is shown to correspond formally to the other.

The logical form itself is not another thing, but an abstract concept, or better an *abstractable* concept. We usually don't abstract it deliberately, but only use it, as we use our vocal cords in speech without first learning all about their operation and then applying our knowl-edge. Most people perceive intuitively the similarity of their two hands without thinking of them as conversely related; they can guess at the shape of the hollow inside a wooden shoe from the shape of a human foot, without

any abstract study of topology. But the first time they see a map in the Mercator projection—with parallel lines of longitude, not meeting at the poles—they find it hard to believe that this corresponds logically to the circular map they used in school, where the meridians bulged apart toward the equator and met at both poles. The visible shapes of the continents are different on the two maps, and it takes abstract thinking to match up the two representations of the same earth. If, however, they have grown up with both maps, they will probably see the geographical relationships either way with equal ease, because these relationships are not *copied* by either map, but *expressed*, and expressed equally well by both; for the two maps are different *projections* of the same logical form, which the spherical earth exhibits in still another—that is, a spherical—projection.

An expressive form is any perceptible or imaginable whole that exhibits relationships of parts, or points, or even qualities or aspects within the whole, so that it may be taken to represent some other whole whose elements have analogous relations. The reason for using such a form as a symbol is usually that the thing it represents is not perceivable or readily imaginable. We cannot see the earth as an object. We let a map or a little globe express the relationships of places on the earth, and think about the earth by means of it. The understanding of one thing through another seems to be a deeply intuitive process in the human brain; it is so natural that we often have difficulty in distinguishing the symbolic expressive form from what it conveys. The symbol seems to be the thing itself, or contain it, or be contained

in it. A child interested in a globe will not say: "This means the earth," but: "Look, this is the earth." A similar identification of symbol and meaning underlies the widespread conception of holy names, of the physical efficacy of rites, and many other primitive but culturally persistent phenomena. It has a bearing on our perception of artistic import; that is why I mention it here.

The most astounding and developed symbolic device humanity has evolved is language. By means of language we can conceive the intangible, incorporeal things we call our *ideas*, and the equally inostensible elements of our perceptual world that we call *facts*. It is by virtue of language that we can think, remember, imagine, and finally conceive a universe of facts. We can describe things and represent their relations, express rules of their interactions, speculate and predict and carry on a long symbolizing process known as reasoning. And above all, we can communicate, by producing a serried array of audible or visible words, in a pattern commonly known, and readily understood to reflect our multifarious concepts and percepts and their interconnections. This use of language is *discourse;* and the pattern of discourse is known as *discursive form*. It is a highly versatile, amazingly powerful pattern. It has impressed itself on our tacit thinking, so that we call all systematic reflection "discursive thought." It has made, far more than most people know, the very frame of our sensory experience—the frame of objective facts in which we carry on the practical business of life.

Yet even the discursive pattern has its limits of usefulness. An expressive form can express any complex of

conceptions that, via some rule of projection, appears congruent with it, that is, appears to be of that form. Whatever there is in experience that will not take the impress—directly or indirectly—of discursive form, is not discursively communicable or, in the strictest sense, logically thinkable. It is unspeakable, ineffable; according to practically all serious philosophical theories today, it is unknowable.

Yet there is a great deal of experience that is knowable, not only as immediate, formless, meaningless impact, but as one aspect of the intricate web of life, yet defies discursive formulation, and therefore verbal expression: that is what we sometimes call the *subjective aspect* of experience, the direct feeling of it—what it is like to be waking and moving, to be drowsy, slowing down, or to be sociable, or to feel self-sufficient but alone; what it feels like to pursue an elusive thought or to have a big idea. All such directly felt experiences usually have no names—they are named, if at all, for the outward conditions that normally accompany their occurrence. Only the most striking ones have names like "anger," "hate," "love," "fear," and are collectively called "emotion." But we feel many things that never develop into any designable emotion. The ways we are moved are as various as the lights in a forest; and they may intersect, sometimes without cancelling each other, take shape and dissolve, conflict, explode into passion, or be transfigured. All these inseparable elements of subjective reality compose what we call the "inward life" of human beings. The usual factoring of that life-stream into mental, emotional, and sensory units is an arbitrary scheme of

simplification that makes scientific treatment possible to a considerable extent; but we may already be close to the limit of its usefulness, that is, close to the point where its simplicity becomes an obstacle to further questioning and discovery instead of the revealing, ever-suitable logical projection it was expected to be.

Whatever resists projection into the discursive form of language is, indeed, hard to hold in conception, and perhaps impossible to communicate, in the proper and strict sense of the word "communicate." But fortunately our logical intuition, or form-perception, is really much more powerful than we commonly believe, and our knowledge—genuine knowledge, understanding—is considerably wider than our discourse. Even in the use of language, if we want to name something that is too new to have a name (e.g., a newly invented gadget or a newly discovered creature), or want to express a relationship for which there is no verb or other connective word, we resort to metaphor; we mention it or describe it as something else, something analogous. The principle of metaphor is simply the principle of saying one thing and meaning another, and expecting to be understood to mean the other. A metaphor is not language, it is an idea expressed by language, an idea that in its turn functions as a symbol to express something. It is not discursive and therefore does not really make a statement of the idea it conveys; but it formulates a new conception for our direct imaginative grasp.

Sometimes our comprehension of a total experience is mediated by a metaphorical symbol because the experience is new, and language has words and phrases only for

familiar notions. Then an extension of language will gradually follow the wordless insight, and discursive expression will supersede the non-discursive pristine symbol. This is, I think, the normal advance of human thought and language in that whole realm of knowledge where discourse is possible at all.

But the symbolic presentation of subjective reality for contemplation is not only tentatively beyond the reach of language—that is, not merely beyond the words we have; it is impossible in the essential frame of language. That is why those semanticists who recognize only discourse as a symbolic form must regard the whole life of feeling as formless, chaotic, capable only of symptomatic expression, typified in exclamations like "Ah!" "Ouch!" "My sainted aunt!" They usually do believe that art is an expression of feeling, but that "expression" in art is of this sort, indicating that the speaker has an emotion, a pain, or other personal experience, perhaps also giving us a clue to the general kind of experience it is—pleasant or unpleasant, violent or mild—but not setting that piece of inward life objectively before us so we may understand its intricacy, its rhythms and shifts of total appearance. The differences in feeling-tones or other elements of subjective experience are regarded as differences in quality, which must be felt to be appreciated. Furthermore, since we have no intellectual access to pure subjectivity, the only way to study it is to study the symptoms of the person who is having subjective experiences. This leads to physiological psychology—a very important and interesting field. But it tells us noth-

ing about the phenomena of subjective life, and sometimes simplifies the problem by saying they don't exist.

Now, I believe the expression of feeling in a work of art—the function that makes the work an expressive form—is not symptomatic at all. An artist working on a tragedy need not be in personal despair or violent upheaval; nobody, indeed, could work in such a state of mind. His mind would be occupied with the causes of his emotional upset. Self-expression does not require composition and lucidity; a screaming baby gives his feeling far more release than any musician, but we don't go into a concert hall to hear a baby scream; in fact, if that baby is brought in we are likely to go out. We don't want self-expression.

A work of art presents feeling (in the broad sense I mentioned before, as everything that can be felt) for our contemplation, making it visible or audible or in some way perceivable through a symbol, not inferable from a symptom. Artistic form is congruent with the dynamic forms of our direct sensuous, mental, and emotional life; works of art are projections of "felt life," as Henry James called it, into spatial, temporal, and poetic structures. They are images of feeling, that formulate it for our cognition. What is artistically good is whatever articulates and presents feeling to our understanding.

Artistic forms are more complex than any other symbolic forms we know. They are, indeed, not abstractable from the works that exhibit them. We may abstract a shape from an object that has this shape, by disregarding color, weight and texture, even size; but to the total effect that is an artistic form, the color matters, the

thickness of lines matters, and the appearance of texture and weight. A given triangle is the same in any position, but to an artistic form its location, balance, and surroundings are not indifferent. Form, in the sense in which artists speak of "significant form" or "expressive form," is not an abstracted structure, but an apparition; and the vital processes of sense and emotion that a good work of art expresses seem to the beholder to be directly contained in it, not symbolized but really presented. The congruence is so striking that symbol and meaning appear as one reality. Actually, as one psychologist who is also a musician has written, "Music sounds as feelings feel." And likewise, in good painting, sculpture, or building, balanced shapes and colors, lines and masses look as emotions, vital tensions and their resolutions feel.

An artist, then, expresses feeling, but not in the way a politician blows off steam or a baby laughs and cries. He formulates that elusive aspect of reality that is commonly taken to be amorphous and chaotic; that is, he objectifies the subjective realm. What he expresses is, therefore, not his own actual feelings, but what he knows about human feeling. Once he is in possession of a rich symbolism, that knowledge may actually exceed his entire personal experience. A work of art expresses a conception of life, emotion, inward reality. But it is neither a confessional nor a frozen tantrum; it is a developed metaphor, a non-discursive symbol that articulates what is verbally ineffable—the logic of consciousness itself.

3

CREATION

It is customary to speak of an artist's work as "creation." A painter "creates" a painting. A dancer "creates" a dance, a poet "creates" a poem. If he slumps and gets nothing done he is apt to worry about not being "creative" (which usually makes him even more uncreative).

But when a factory worker, say a candy dipper or a weaver, has a sore throat and stays away from work he is not called "uncreative"; in fact, he may take that professionally idle day at home to play piano—which doesn't produce any material object at all—and then he is said to be creating music. Why? Why is a piece of music a creation and a shoe usually just a product? The distinction, though it is protested by some philosophers who are anxious champions of democracy, like John Dewey, is a commonly accepted one. An automobile is not created on the conveyor belt, but manufactured. We don't create bricks, aluminum pots, or toothpaste; we simply make such things. But we create works of art.

There is a special justification for the term; the distinction has nothing to do with undemocratic valuations. Creation is not properly a value-concept, as it is taken to be by milliners and caterers who speak of their products as "creations." Some pathetic artists create mediocre or even quite vulgarly sentimental pictures, banal songs, stupid dances, or very bad poems; but they create them.

The difference between creation and other productive work is this: an ordinary object, say a shoe, is made by putting pieces of leather together; the pieces were there before. The shoe is a construction of leather. It has a special shape and use and name, but it is still an article of leather, and is thought of as such. A picture is made by deploying pigments on a piece of canvas, but the picture is not a pigment-and-canvas structure. The picture that emerges from the process is a structure of space, and the space itself is an emergent whole of shapes, visible colored volumes. Neither the space nor the things in it were in the room before. Pigments and canvas are not in the pictorial space; they are in the space of the room, as they were before, though we no longer find them there by sight without a great effort of attention. For touch they are still there. But for touch there is no pictorial space.

The picture, in short, is an apparition. It is there for our eyes but not for our hands, nor does its visible space, however great, have any normal accoustical properties for our ears. The apparently solid volumes in it do not meet our common-sense criteria for the existence of objects; they exist for vision alone. The whole picture is a piece of purely visual space. It is nothing but a vision.

There are certain merely apparent objects in nature: rainbows, mirages, and simple reflections in still water or on other shiny surfaces. The most familiar instances are images, in mirrors which we construct for the purpose of getting reflections. It is the mirror that has made physicists recognize and describe this sort of space, which by the usual standard of practical experience is illusory; they call it *virtual space*. Let us borrow that technical term, "virtual."

A picture is an apparition of virtual objects (whether they be "things" in the ordinary sense or just colored volumes), in a virtual space. But it differs from a reflection in a quite radical way: there is nothing in actual space (by actual space I mean our normal space, in which we act) related to the painting as a physical object is related to its own mirror image. The space behind the mirror is really an indirect appearance of actual space. But the virtual space of a painting is *created*. The canvas existed before, the pigments existed before; they have only been moved about, arranged to compose a new physical object, that the painter calls "my big canvas" or "that little new canvas." But the picture, the spatial illusion, is new in the sense that it never existed before, anywhere, nor did any of its parts. The illusion of space is created.

As soon as you mention the word "illusion" in connection with art you are likely to start a storm of protests against things you haven't said, but are assumed to think and expected to say. "But art isn't mere illusion! It's the highest Reality!" "But art isn't mere make-believe!" "Beauty is Truth, not mere fancy!" "But art as illusion means mere escapism!" And so forth. Naturally, I should

like to avoid a word that conjures up so much mereness. Yet I have to talk about the subject, for illusion is an important principle in art—a cardinal principle, whereby artistic abstraction is achieved without any process of generalization such as we use in reaching scientific abstractions. The role of illusion is an interesting one, and has nothing to do with make-believe, deception, or escape from truth. It serves the serious, paramount purpose of art, which Flaubert declared to be "expression of the Idea." He could not further define what he meant by "the Idea"; but, as I sought to demonstrate in the preceding lecture, this elusive "Idea" is the conception of subjective experience, the life of feeling.

There, also, I remarked that when artists speak of form they mean something abstract, though a work of art is a concrete, unique entity. They mean something more than physical shape, even where shape happens to be its chief element. The form created by a sculptor is deeply influenced by the color and texture of the material he has shaped. A casting has to be carefully toned and finished if it is to be more than a shape—if it is to present itself as an expressive form. We have to see in it the symbolic possibilities of "form" in the larger sense, logical form. But logical form is not visible, it is conceptual. It is abstract; yet we do not abstract it from the work of art that embodies it. Somehow in perceiving the work, we see it not as *having* an expressive form, but as *being* one. If we see with an artist's eye, as appreciative people do, we see this concrete entity abstractly. How is that brought about?

Ordinarily, we see the shapes, configurations, colors,

movements, in short: the *appearances* of things without being aware of them as particular appearances. We use them only as indications of the things in question. If you come into a room in normal indoor daylight, you may see that it contains, say, a red-covered sofa, but you do not notice the gradations of red or even the appearance of other colors caused by the way the light strikes that sofa at that moment. An eminent art critic, the late Roger Fry, noted this fact many years ago, and expressed it so well that I shall read you what he said:

"The needs of our actual life are so imperative that the sense of vision becomes highly specialized in their service. With an admirable economy we learn to see only so much as is needful for our purposes; but this is in fact very little. . . . In actual life the normal person really only reads the labels as it were, on the objects around him and troubles no further. Almost all the things which are useful in any way put on more or less this cap of invisibility. It is only when an object exists in our lives for no other purpose than to be seen that we really look at it, as for instance at a China ornament or a precious stone, and towards such even the most normal person adopts to some extent the artistic attitude of pure vision abstracted from necessity."

The surest way to abstract the element of sensory appearance from the fabric of actual life and its complex interests, is to create a sheer vision, a datum that is nothing but appearance and is, indeed, clearly and avowedly an object only for sight (let us limit ourselves, for the moment, to pictorial art). That is the purpose of illusion in art: it effects at once the abstrac-

tion of the visual form and causes one to see it as such. What prevents us from treating the volumes of light and color that we see in a picture chiefly as "labels" of things, is that there are no things, and we know it. That knowledge liberates us, without any effort on our part, from what Coleridge called "the world of selfish solicitude and anxious interest" and makes it natural for the beholder of a work to see what it really looks like. In looking at a picture, we neither believe nor make believe that there is a person or a bridge or a basket of fruit in front of us. We do not pass intellectually beyond the vision of space at all, but understand it as an apparition. The normal use of vision, which Fry talked about, is suspended by the circumstance that we know this space to be virtual, and neither believe nor disbelieve in the existence of the objects in it. So we see it as a pure perceptual form, created and articulated by all the visible elements in it: an autonomous, formed space.

To create a sensory illusion is, then, the artist's normal way of making us see abnormally, abstractly. He abstracts the visual elements of experience by cancelling out all other elements, leaving us nothing to notice except what his virtual space looks like. This way of achieving abstraction is different from the usual way practiced in logic, mathematics, or science. In those realms, i.e., the realms of discursive thinking, the customary way to pass from concrete experience to conceptions of abstract, systematic relation patterns is through a process of generalization—letting the concrete, directly known thing stand for all things of its kind. Even when scientific thought has not reached the abstract

level—when it still deals with quite concrete things, like apples or cubes of wood—it is always general. Discursive language—or better, with prudent regard for the theory of poetry, language used for discourse—is intrinsically general. Wider and wider generalization is the method of scientific abstraction. I cannot elucidate that statement any further without digressing from our present theme, and it is not necessary in this connection to understand it; the point I wish to make is simply that in science one attains abstract concepts by way of more and more *general ideas*.

Art does not generalize. If an artist is to abstract a "significant form" (to use Clive Bell's famous phrase) he has to make the abstraction directly by means of one concrete incarnation. This concrete entity is going to be the sole symbol of its import. He must, then, have very powerful means to emphasize the expressive form, which makes the work a symbol, and to show up that form so forcibly that we perceive it, without seeing it repeated from instance to instance, but just in this one exemplification, this organized unit of space. To make us not construe it, but *see* it as a form expressing vital and emotive conceptions, he has to uncouple it from nature, which we see in a different way, namely the way Roger Fry so aptly described. He does it by creating a pure image of space, a virtual space that has no continuity with the actual space in which he stands; its only relation to actual space is one of difference, otherness.

This characteristic way in which the artist presents his formal structure in a single exemplification is, I

think, what makes it impossible to divorce the logical form from its one embodiment or expression. We never pass beyond the work of art, the vision, to something separately thinkable, the logical form, and from this to the meaning it conveys, a feeling that has this same form. The dynamic form of feeling is seen *in* the picture, not through it mediately; the feeling itself seems to be in the picture. Symbolic form, symbolic function, and symbolized import are all telescoped into one experience, a perception of beauty and an intuition of significance. It is unfortunate for epistemology that a mental process can be so complex and concentrated; but perception of artistic import, or what we commonly call "appreciation," certainly seems to be such a distillate of intuition, and the heroic feat of making logical form evident in a single presentation accounts for the fact that we feel rather than know it, conceive vital experience in terms of it, without completing any conscious logical abstraction.

All this explanation of the role played by illusion in artistic abstraction has undoubtedly seemed very difficult (which it is); the upshot of it, however, is that illusion in the arts is not pretense, make-believe, improvement on nature, or flight from reality; illusion is the "stuff" of art, the "stuff" out of which the semi-abstract yet unique and often sensuous expressive form is made. To call the art-image illusory is simply to say that it is not material; it is not cloth and paint-smooches, but space organized by balanced shapes with dynamic relations, tensions and resolutions, among them. Actual space is not like that; it has no organic form, like pictorial space.

Pictorial space is a symbolic space, and its visual organization is a symbol of vital feeling.

This brings us to the second point of major interest in dealing with the problem of creation: the question of what makes the different arts as different as we find them. That question naturally arises as soon as we try to apply the theory of illusion which I have just presented, to other than plastic arts. How can one extend the concept of "virtual space" to music? Or to poetry? To the novelist's art? What role does it play there?

The concept of "virtual space" is not simply transferable from the aesthetics of painting to the aesthetics of music. There is such a thing as virtual space in music, but it does not hold the position of central importance there that it holds in the visual arts. But we have a corresponding central concept; music also has its unreal, created "stuff" of which its forms are made.

In painting, virtual space may be called the *primary illusion*, not because it is what the artist makes first, before he creates forms in it—it comes with the lines and colors, not before them—but because it is what is *always* created in a work of pictorial art. Even bad pictures create a picture space, otherwise we would not see them as pictures, but as spotted surfaces. A spotted surface is "bad" only if we feel called upon to clean it up. A picture is bad if it is inexpressive, dead.

So far we have considered only pictures as plastic art; there are, of course, other plastic works, notably sculptures and buildings. These forms do not so obviously create an illusion as pictures do. Yet they do exist for vision in their own space, unrelated to the space of

science or practicality; and without representing anything, they *present themselves* so forcibly to vision that they seem to exist for that sense alone. The virtual space they create is not pictorial space, but a different mode of spatial apparition. We cannot possibly go into that matter here. I merely mention it so as to forestall a misgiving that would surely arise in every critic's mind were I to treat pictorial space as the sum and substance of all plastic art.

Virtual space, however, in its various modes, is the primary illusion of all such art. It is created in every work that we recognize as plastic expression, and its primary character defines the realm of plastic art.

Music, too, has its primary illusion, which is created whenever tonal materials beget a musical impression. A hasty sketch of so large a subject as the nature of music cannot sound very convincing, especially when it is presented in parallel to a theory of painting; it is apt to seem like a simple, somewhat pat analogy. Actually, this whole theory of art stems from the problem of "meaning" in music.

Music also presents us with an obvious illusion, which is so strong that despite its obviousness it is sometimes unrecognized because it is taken for a real, physical phenomenon: that is the appearance of *movement*. Music flows; a melody moves; a succession of tones is heard as a progression. The differences between successive tones are steps, or jumps, or slides. Harmonies arise, and shift, and move to resolutions. A complete section of a sonata is quite naturally called a "movement."

People have often tried to explain this inescapable

impression of motion by the fact that sound is caused by vibrations, which are physical motions. But the motions of strings, membranes, or tubes are extremely small, rapid, and repetitious; they are no more like the movement of a simple melody toward its keynote than the spatial relations of pigments on a canvas are like the relations of sky and breakers in a seascape. We do not hear vibratory motions in music, but large linear movements, mounting harmonies, rhythms that are not at all like physical oscillations. We hear marching, flowing, or driving progressive motion. Yet in a musical progression there is nothing that is displaced, that has gone from somewhere to somewhere else. Musical movement is illusory, like volumes in pictorial space.

By means of this purely apparent movement, music presents an auditory apparition of *time;* more precisely, of what one might call "felt time." Instead of vaguely sensing time as we do through our own physical life-processes, we hear its passage. But this passage is not a simple one-dimensional trickle of successive moments, as it is in the conceptual framework of classical physics with which we usually operate in practical life. Musical time is not at all like clock-time. It has a sort of voluminousness and complexity and variability that make it utterly unlike metrical time. That is because our direct experience of time is the passage of vital functions and lived events, felt inwardly as tensions—somatic, emotional, and mental tensions, which have a characteristic pattern. They grow from a beginning to a point of highest intensity, mounting either steadily or with varying acceleration to a climax, then dissolving, or letting

go abruptly in sudden deflation, or merging with the rise or fall of some other, encroaching tension.

Since living beings are indescribably complex, the tensions that compose the vital process are not simply successive, but have multiple, often incommensurable relations. They form a dense fabric in which most of them are obscured; only a few dominant strains can exist consciously in any given phase. The others compose a qualitative rather than quantitative ingredient of temporal experience. That is why subjective time seems to have density and volume as well as length, and force as well as rate of passage. The one-dimensional time of Newtonian physics, and its derivative, the time-dimension in modern physical theory, are abstractions from our experience of time. They have tremendous social and intellectual advantages, but they are very specialized abstractions, and leave many aspects of our direct knowledge outside the realm of discursive thought which they dominate.

This theory of musical creation has an interesting counterpart, namely the theory of musical (as against actual) hearing. If music is indeed time made audible, then that is what the auditor ought to hear: virtual movement, motion that exists only for the ear. No tangible thing is actually going from one place to another. But the listener hears musical figures that move through a definite tonal range, from points of origin to points of relative rest; he hears tonal qualities as intense as colors, steadily or briefly holding places in the stream. Melodies and harmonic masses within it build up tensions like growing emotions, and resolve them or merge them into

38

new tensions. Also, in clearest demonstration of the difference between materials and elements, we hear something in music that does not exist outside of it at all: sustained rest. If a figure ascends to a resting tone, the actual motion of the air is faster on that resting tone than anywhere else in the passage; but what we hear is changeless continuity in time, sustained rest.

Sonorous moving forms—"tönend bewegte Formen," as Hanslick said—are the elements of music. The *materials* of music, on the other hand, are sounds of a certain pitch, loudness, overtone mixture, and metronomic length. In artistic production, the composer's materials must be completely swallowed up in the illusion they create, in which henceforth we find only illusory elements, but not—except through technical interest and workmanlike attention—the arrangement of materials. The illusory elements are figures, motions, and what we call "colors," "spaces," tensions and resolutions, resting tones, emptiness, beginnings and ends.

I think the confusion between materials and elements is the crux of most difficulties in art theory, and even the cause of some practical errors that arise from superficial theory. As long as you think of music in terms of arranged tonal material, you are ridden with all the traditional problems of what to allow or not to allow, of pure or impure music, hybrid arts, classical patterns and free combinations, and so on. But as soon as you think of it as moving tonal forms creating an organic, purely virtual image of subjective time in its passage, these problems evaporate. Anything belongs to music that helps to make, sustain, and articulate the illusion;

39

noises as well as tones, words, even dramatic actions. There is no impure music, but only good and bad music. Bad music may be made of pure tones in quite orthodox arrangement; good and absolutely pure music may need the support of words, as plain chant does, or completely swallow actions and scenes, persons and décor, as Mozart's operas do.

Furthermore, the belief that in order to express "modern feeling" you need new tone-producing devices, and that the modern composer has some obligation to explore all the new sonorous possibilities that science puts at his disposal, seems to me to be fallacious. He has the *right* to use any materials he likes; but even if he wants to express emotional conditions of which his forbears knew nothing, he may or may not need new sounds. His purpose is to create new elements, and how he will do it is a problem for his tonal imagination and his conception of feeling.

But the moral of this disquisition is not for the composer alone. The audience, too, is prone to be misled by the reverberations of incoherent art theory that one gets in program notes and criticism. Most auditors at concerts are sure they cannot understand the way modern music is "put together." They think that in order to appreciate it they must be able to detect the structure, name the chords, recognize all its devices, and spot the instruments that are used in each passage. Such perception is really a natural result of shopwork, and also to some extent of much concert-going; but it is not a requisite for musical intuition. What the audience should hear is *musical elements*—created moving forms, **or**

even, with apparent immediacy, a flow of life, feeling, and emotion in audible passage. Often the actual tonal materials are blended so as *not* to be separately heard, to create a tone-quality in which strings and winds, for instance, are secret ingredients. The listener, untroubled by self-consciousness and an intellectual inferiority-complex, should hear what is created to be heard. I think the greater part of a modern audience listening to contemporary music tend to listen so much for new harmonies and odd rhythms and for new tone-mixtures that they never receive the illusion of time made audible, and of its great movement and subordinate play of tensions, naively and musically at all.

Now in conclusion, let us return to our main topic.

Music unfolds in a virtual time created by sound, a dynamic flow given directly and, as a rule, purely to the ear. This virtual time, which is an image not of clock-time, but of lived time, is the primary illusion of music. In it melodies move and harmonies grow and rhythms prevail, with the logic of an organic living structure. Virtual time is to music what virtual space is to plastic art: its very stuff, organized by the tonal forms that create it.

Every great order of art has its own primary illusion; that is what sets the great orders apart. There are many criss-cross relations among them—relations between music and poetry, between poetry and plastic design, and so forth. To insist *ab initio* that the fundamental distinctions among the several art genders are unimportant does not make their close interrelations more evident or more lucid; on the contrary, it makes them inscrutable.

41

The unity of art is then asserted as an article of faith, instead of a reasonable proposition, as I find it to be.

But the principle of creation is the same in all the arts, even if that which is created differs from one to another. Every work of art is wholly a creation; it does not have illusory and actual elements commingling in it. Materials are actual, but art elements are always virtual; and it is elements that an artist composes into an apparition, an expressive form.

Because this form is given either to just one sense, or to imagination (as poetry is), or is given so forcibly to sense that its other properties become irrelevant (as a fine vase or a beautiful building presents itself so emphatically to the eye that it acts like a vision), we see this sensuous or poetic form *in abstracto*, that is, we really perceive the form, instead of merely using it in a half-conscious way as an indication of a physical thing or a fact. The artistic abstraction of form for experience is made by creating a pure apparition that has, or seems to have, no practical involvements at all. That is the cardinal function of illusion. Such illusion is neither deception nor make-believe; it is exactly the opposite, make-*not*-believe, though it does not invite *un*belief, either. It just cancels the usual process of factual judgment, and with it all inclination to go beyond the vision, the expressive form, to something else.

Once the work is seen purely as a form, its symbolic character—its logical resemblance to the dynamic forms of life—is self-evident. We need not even take discursive account of it; we see or hear unity, organic integrity, development, growth, and feeling "expressed" in the

42

apparition before us. We perceive them when we see or hear or read the work, and they seem to be directly contained in it, not symbolized by it. The work itself takes on the semblance of life: when artists speak of "living form" they mean something in art, not in biology. But that is tomorrow's problem.

4

LIVING FORM

One of the most widely used metaphors in the literature of art is the metaphor of the living creature applied to the artistic product. Every artist finds "life," "vitality," or "livingness" in a good work of art. He refers to the "spirit" of a picture, not meaning the spirit in which it was painted, but its own quality; and his first task is to "animate" his canvas. An unsuccessful work is "dead." Even a fairly good one may have "dead spots." What do people mean when they speak as though a picture or a building or a sonata were a living and breathing creature?

Another metaphor of the studio, borrowed from the biological realm, is the familiar statement that every art work must be organic. Most artists will not even agree with a literal-minded critic that this is a metaphor. "Organic" simply and directly refers, in their vocabulary, to something characteristic of good pictures and statues, poems and plays, ballets and buildings and pieces of music. It does not refer to biological functions like digestion and circulation. But—breathing? Heartbeat?

Well, maybe. Mobility? Yes, perhaps. Feeling? Oh yes, certainly.

For a work to "contain feeling," as that phrase is commonly used, is precisely to be alive, to have artistic vitality, to exhibit "living form." We discussed yesterday why a form that expresses feeling appears not merely to connote it, as a meaning, but to contain it, as a quality. Since, however, we know that for a work to contain feeling is really to be an expressive form which articulates feeling, we may well ask, at this point, why such articulation requires a symbol having the appearance of vital organization and autonomous life; and furthermore, how this appearance is achieved. For, certainly, works of art are not really organisms with biological functions. Pictures do not really pulse and breathe; sonatas do not eat and sleep and repair themselves like living creatures, nor do novels perpetuate their kind when they are left unread in a library. Yet the metaphors of "life" and "organic form" in art are so strong that I have known a serious, reflective artist to be actually shocked at such philistine statements as I have just made, calling those terms metaphors.

Let us consider, first, what feeling and emotion have to do with organic life; secondly, what are the characteristics of actual organisms; thirdly, what are the most general features of artistic creation by virtue of which the semblance of life is produced, and finally, how this semblance empowers the artist to imagine and articulate so much of human mentality, emotion, and individual experience as men of genius do in fact put before us.

Sentience—the most elementary sort of consciousness

45

—is probably an aspect of organic process. Perhaps the first feeling is of the free flow or interruption of vital rhythms in the creature itself, as the whole organism interacts with the surrounding world. With higher phases of functional development, more specialized sentience develops, too—sensations, distinct emotions rather than total, undifferentiated excitements, desires in place of bodily discomfort, directed drives and complex instincts, and with every complication of activity a richer subjective immediacy.

It is a misconception, I believe, to think of sentience as something *caused* by vital activities. It is not an effect, but an aspect of them; as the red of an apple is not caused by the apple, but is an aspect of the apple itself in its mature phase. Sentience arises *in* vital functioning rather than *from* it; life as such is sentient. Naturally, then, life as it is felt always resembles life as it is observed; and when we become aware of feeling and emotion as ingredients in a non-physical nexus, the mind, they still seem to lie close to the somatic and instinctive level of our being. They are, indeed, like high-lights on the crests of the turbulent life-stream. Naturally, then, their basic forms are vital forms; their coming and going is in the pattern of growth and decline, not of mechanical occurrences; their mutual involvements reflect the mold of biological existence. If, therefore, a created sensuous symbol—a work of art—is to be in their image, it must present itself somehow as a version, or projection, of living process; it must be of a logical form that is commensurable with the essential forms of life.

What are the distinctive features of life? What properties divide living from non-living things?

All living matter that we have identified as such is organic; living creatures are organisms. They are characterized by what we call organic process—the constant burning-up and equally constant renewal of their substance. Every cell, and indeed every part of every cell (and the functionally distinct parts are infinitesimal), is perpetually breaking down, and perpetually being replaced. The cell, the tissue composed of diverse cells, the organ to which the tissue belongs, the organism that subsumes the organ—that whole vast system is in unceasing flux. It actually has no sameness of material substance from second to second. It is always changing; and if the exchanges of matter stop for even a few seconds, the effect is cataclysmic; the system is destroyed. Life is gone.

An organism, which seems to be the most distinct and individual sort of thing in the world, is really not a *thing* at all. Its individual, separate, thing-like existence is a pattern of changes; its unity is a purely functional unity. But the integration of that functional whole is so indescribably complex and intimate and profound that the self-identity of the higher organisms (that is, the most elaborately integrated ones) is more convincing than the self-identity of the most permanent material concretion, such as a lump of lead or a stone. If you reflect on this strange fact, you realize why human identity is always felt to lie not so much in bodily permanence as in personality. It is a functional identity, a pattern of physical and mental process, a continuum of activity.

Let us hark back, for a moment, to a concept that was discussed in the first lecture—the concept of *dy-*

namic form. You may remember that the example we considered there was a waterfall. You can photograph a waterfall with an ordinary little camera, if you stand back enough, just as you can photograph a house or a mountain. The waterfall has a shape, moving somewhat, its long streamers seeming to shift like ribbons in a wind, but its mobile shape is a permanent datum in the landscape, among rocks and trees and other things. Yet the water does not really ever stand before us. Scarcely a drop stays there for the length of one glance. The material composition of the waterfall changes all the time; only the form is permanent; and what gives any shape at all to the water is the motion. The waterfall exhibits a *form of motion,* or a *dynamic form.*

If you put a dot of color on the rim of a wheel and spin it, you see a colored circle instead of a dot. This again is the form of the dot's motion—a purely dynamic form—made visible.

Vital form is always dynamic. An organism, like a waterfall, exists only while it keeps going. Its permanence is not endurance of a material, but of a functional pattern. The most elementary feeling, therefore—one might say, the sheer sense of life—is a sense of that dialectic of permanence and change that governs the existence of every cell, every fibre in a living creature. That is the foundation of what Henry James called "felt life."

But dynamic form is not enough. A waterfall is not an organism. The waterfall has no biography. It cuts its groove into the resisting rock; its own shape changes somewhat with that process, and very much more with

any changes in the water supply, with hot and cold weather, etc.—but under steady conditions the waterfall does not grow, age, decline, and cease forever, as an organism does. If the water source fails, the fall stops, but with renewed supply it begins again.

An organism has an entirely different relation to the outside world from that of a simple dynamism like the waterfall. It is also a dynamism, but not a stream; it contains a myriad of distinct activities represented by permanent structures, and coinciding with each other in ways that seem a miracle of timing and complementation. All its processes form a single system. In the higher organisms, certain very elaborate processes acquire control over the simpler and perhaps phylogenetically older ones; in man, for instance, the nervous system is so involved with all the other organic functions that any extensive injury done to it is likely to disturb or even abrogate the whole functional system. The organism is, to a great extent, inviolable if it is to exist at all. It can undergo many changes, survive many accidents, but only as long as the basic process of life goes on.

This basic process is the constant breaking down and reconstitution of every living part. For an organism is always taking in material that is not of its own system, splitting it up, and transforming some of it into living matter. Concomitantly, some living matter is always breaking down and resigning from the total activity. The one process is growth, and the other decay. Every organism is always both growing and decaying. When growth exceeds decay, the system increases (the process we commonly mean by "growth"); when they are

evenly balanced, it maintains itself; when decay has the ascendancy, it ages. Finally, growth stops all at once; the life is done, and decay quickly dissolves the whole structure.

The character of inviolability and fragility marks all living things. Even the most persistent—redwood trees, and very long-lived creatures like crocodiles—are always maintaining themselves precariously against ravaging influences, from temperature-changes and bacterial blights to the brute hand of man. The nature of life is transient; even without accident, it is a passage from youth to age, no matter what its span.

The reason why so complex a network of events as the life of an individual can possibly go on and on in a continuous dynamic pattern is, that this pattern of events is rhythmic. We all know that many of our actions, like walking, rowing, even wood-chopping and rug-beating, are more easily done when they are rhythmic. People usually think of rhythm as a succession of similar events at fairly short, even intervals of time; that is, they think of rhythm as *periodic succession*. But what about a tennis player whose motions impress one as rhythmic? He probably does not repeat a single action; even his step is less metrical than that of a drunkard walking. What, then, is rhythm?

It is, I think, something related to *function* rather than to time. What we call an *event* is not simply anything that goes on in an arbitrary segment of time. An event is a change in the world having a beginning and a completion. The fall of an apple is the sort of thing we mean, ordinarily, by an event; it begins with the breaking of

the stem from the twig that bears it, and ends with the apple's coming to rest somewhere. Its falling may include its rolling on the ground, or we may call that another event, and say that after the apple fell it rolled. At any rate, what we identify as an event in nature (except for certain highly specialized, scientific purposes) is not something instantaneous, but a change that is begun and completed.

A rhythmic pattern arises whenever the completion of one distinct event appears as the beginning of another. The classic example is the swinging of a pendulum. The momentum of its drop drives the weight upward in the opposite direction, and builds up the potential energy that will bring it down again; so the first swing prepares the second; the second swing was actually begun in the first one, and similarly, after that, each swing is prepared by the one before. The result is a rhythmical series. Or, consider the breaking of waves in a steady surf on a beach: the momentum of the water drives it up the beach, until that momentum is spent, and the slant of the shore causes the water to run seaward again; but the piling of the second, incoming wave is also sucking back the spent water, and making its return a downward rush, that stops the bottom part of the new wave and causes it to break over itself. Here, again, is a rhythmic pattern. The completion of each breaker's history is already the beginning of the next one's.

In a living organism, practically all activities are rhythmically conditioned, sometimes interconnected not only by one chain of events but by many, functioning in many different rhythmic relationships at once. The most

obvious rhythmic processes are, of course, heartbeat and breath. In the heart, every systole starts a diastole, and vice versa. In breathing, the process starts all the time throughout the whole body; as the oxygen of a breath is used up, it builds up the imperative need of oxygen that is really the beginning of the new breath. This sort of mutual conditioning is the law of organic function; the more closely you look into the entire physiological process that constitutes the dynamic form we call "life," the more minutely, diversely, and elaborately rhythmic it proves to be. In every cell, the very process of its oxidation—its burning away, breaking down—is the condition that has already started the chemical change which builds up its characteristic substance again. The rhythmic interaction is incredible.

Many fundamental rhythms in the world are periodic; in fact, so many that periodicity is often taken to be the essence of rhythm. But the view we have just taken of rhythm as a functional involvement of successive events makes periodic rhythms a special sort, despite their immense importance, and lets us see why a tennis player, a wheeling bird, and a modern dancer who does not necessarily repeat any motion may exhibit rhythm, too.

Living form, then, is in the first place dynamic form, that is, a form whose permanence is really a pattern of changes. Secondly, it is organically constructed; its elements are not independent parts, but interrelated, interdependent centers of activity—that is, organs. Thirdly, the whole system is held together by rhythmic processes; that is the characteristic unity of life. If its major rhythms are greatly disturbed, or suspended for

more than a few moments, the organism collapses, life stops. Therefore living form is inviolable form. And finally, the law of living form is the dialectic of growth and decay, with its characteristic biographical phases.

In the higher organisms, secondary rhythms develop, specialized responses to the surrounding world, tensions and their resolutions within the system: emotions, desires, attentive perception and action. Finally, at the human level, instinct is largely replaced by intuition, direct responses by symbolic responses—imagination, memory, reason—and simple emotional excitement is superseded by the continuous, personal life of feeling. But all these typically human functions have evolved from the deeper vital complex, and still exhibit its fundamental traits—its dynamism, inviolable unity, organization, rhythmic continuity, and growth. These are the principles of living form.

If art is, as I believe it is, the expression of human consciousness in a single metaphorical image, that image must somehow achieve the semblance of living form. All the principles we have just considered must have their analogues in those of artistic creation. This is indeed the case. But it must be remembered that analogous principles are not identical. The semblance of life need not be constructed on the same plan as life itself; a device that serves to create a sense of change need not involve any actual change, nor the most forcible presentation of growth any actual accumulation. Artistic form is a projection, not a copy. Consequently there is no direct correlation between the constituents of an organism and the elements in a work of art. Art has its

own laws, which are laws of expressiveness. Its own elements are all created forms, not material ingredients; such elements cannot be compared to physical factors, nor their functions to physical functions. Only their product—the expressive form, the work of art—has characteristics symbolically related to those of life itself.

There are countless devices in the arts for the creation or enhancement of "living form." In the brief hour of a lecture we cannot do more than mention and illustrate a few of the major resources that artists draw upon for this purpose.

As I said earlier today, our sense of change in permanence, the balance of becoming and passing, is one of the profoundest aspects of human consciousness. If we look at even the most elementary forms of visual art— say, a purely decorative design, a wavy line adorning the rim of a pot, a repeated pattern on a cloth—the line, which is stationary, is said to "run" around the rim, and the over-all design, if it is good, seems to spread out over the cloth from any point where we happen to start. Let us talk about the line.

In talking about dynamic form we considered the effect of a dot of color on a rotating wheel: the little dot is seen as a circle, an even, closed line. This line expresses the form not of the dot, but of its motion. It projects this dynamic form as an apparently fixed visual datum, a circular line.

The relationship between lines and motions of objects rests upon the natural laws of our perception. Swift motions are actually seen as motionless lines. Objects that deposit a trail, like a crayon, leave an actual, perma-

nent line; this line, too, expresses the motion of the
object, though it is not physically a dynamic form like
the circle made by the spinning dot. But such a line does
not naturally connote the thing that made it; what it
connotes is only the directedness of its motion. It is a
path; and in our seeing, every continuous line is a path,
though it need not be the path of any imagined thing.

Lines, however, have another function, too: they are
divisions of space, contours that define volumes. Volumes
are the stabilizing elements in our world. In virtual space,
lines express both motion and rest; and as virtual space
is a pure creation, the lines that articulate it create both
motion and rest, and, moreover, create both at the same
time. A contour—as the word itself tells—is a turn, or
path, that carves out a space. The way a line is handled
makes it predominantly a dynamic or a static element, as
the case may be. A space created by lines is *ipso facto*
a temporal space, that is, a spatio-temporal form, which
may readily be molded to express the dialectic of perma-
nence and change which is characteristic of life.

Let us take another basic principle of art, that artists
and critics are forever talking about: organic structure.
Obviously, a picture or a poem does not really have
organs and vital functions. But something about artistic
structure exemplifies the principle of organization, too,
though not in the same way that natural organisms do.

Every element in a work of art is so involved with
other elements in the making of the virtual object, the
work, that when it is altered (as it may be—artists make
many alterations after the composition is well under
way) one almost always has to follow up the alteration

in several directions, or simply sacrifice some desired effects. A key word in a poetic verse, for instance, has literal sense, perhaps obvious metaphorical sense, emotional overtones, grammatical cognates, familiar and unfamiliar uses. Each of these different functions may relate it in a different way from any other. Let us take William Blake's very perfect little poem, "Love's Secret," and examine the functions of a few words in it:

> Never seek to tell thy love,
> Love that never told can be;
> For the gentle wind doth move
> Silently, invisibly.
>
> I told my love, I told my love,
> I told her all my heart,
> Trembling, cold, in ghastly fears.
> Ah! she did depart!
>
> Soon after she was gone from me,
> A traveller came by,
> Silently, invisibly:
> He took her with a sigh.

The first two lines exhibit three repetitions, but all of different degrees. "Never" is exactly repeated, but stands in different relations to the respective lines; "tell" is repeated in different grammatical form, at corresponding points in both lines; "love"—the key word—occurs in diametrically opposed positions, i.e., at the end of one line and the beginning of the next; and in the two clauses which it dominates it has both different meaning and different syntactical value. The first "love" is the indirect object of "tell" and designates a person; the second

"love" is the direct object of the same verb, and desig-
nates an emotion. And the two uses of love are in
juxtaposition, but differently emphasized by the metrical
structure of the lines. They are different elements,
intimately related, at once, by their apparent identity;
then by the shift of sense from one to the other which
makes them homonyms instead; by the fact that their
meanings, though distinct, are cognate; by the fact that
they both complete the sense of the same verb, "tell,"
but in different ways. Finally, they serve in conjunction
to link the two lines in a special way, making them seem
like counterparts, a symmetrical pair. Symmetry is a
strong form; this purely formal strength of the first two
lines makes possible the erratic shift of thought in the
following verses, which is logically, of course, a com-
plete *non sequitur* introduced by the word "for." In the
third line, another function of the word "love" (in its
first occurrence) comes to light: it has also prepared the
rhyme; and to save the poem from too much symmetry,
it is a near-rhyme.

The use of "for" to link the first and second thoughts
is a bold construction; it creates the feeling of a rational
connection where literally there is none; but it refers
the wind's movements—"silently, invisibly"—directly to
love, and transforms them at a stroke into metaphors
for its ineffable nature.

This many-sided involvement of every element with
the total fabric of the poem is what gives it a semblance
of organic structure; like living substance, a work of art
is inviolable; break its elements apart, and they no longer
are what they were—the whole image is gone.

I wish we could analyze all the leading principles; but I have already made great demands on your attention, and the two remaining subjects, rhythm and the illusion of development, or growth, are difficult. So I can only say, in conclusion, that the more you study artistic composition, the more lucidly you see its likeness to the composition of life itself, from the elementary biological patterns to the great structures of human feeling and personality that are the import of our crowning works of art; and it is by virtue of this likeness that a picture, a song, a poem is more than a thing—that it seems to be a living form, created, not mechanically contrived, for the expression of a meaning that seems inherent in the work itself: our own sentient being, Reality.

5

ARTISTIC PERCEPTION AND
"NATURAL LIGHT"

By artistic perception I mean the perception of *expressiveness* in works of art. Expressiveness belongs to every successful work; it is not limited to pictures, poems, or other compositions that make a reference to human beings and their feelings, show looks and gestures or emotionally charged situations. The representation of feeling is one thing, the specifically artistic expression of it is another. A wholly non-representational design, a happily proportioned building, a beautiful pot may, artistically speaking, be just as expressive as a love-sonnet or a religious picture. It has an import which is, I think, a wordlessly presented conception of *what life feels like*. That is the significance of "Significant Form" (to use Clive Bell's much-attacked phrase), the "livingness" Augusto Centeno calls the essence of art, the cryptic "artistic truth" that is independent of facts and actualities. I call it *vital import*: "vital," because it is always

some mode of feeling, sense, emotion, consciousness, that is conveyed by a successful work of art; "import," because it is conveyed. Vital import is the element of *felt life* objectified in the work, made amenable to our understanding. In this way, and in no other essential way, a work of art is a symbol.

But vital import, or artistic expressiveness, cannot be pointed out, as the presence of this or that color contrast, balance of shapes, or thematic item may be pointed out by the discerning critic. You apprehend expressiveness or you do not; it cannot be demonstrated. One may demonstrate that such-and-such ingredients—chords, words, shapes, or what-not—have gone into the structure of the work; one may even point out pleasant or harsh sensory effects, and anybody may note them. But no one can show, let alone prove to us, that a certain vision of human feeling (in the widest sense of the word "feeling") is embodied in the piece. This sort of feeling, which is not represented, but composed and articulated by the entire apparition, the art symbol, is found there directly, or not at all. That finding of a vital import is what I mean by "artistic perception." It is not the same thing as aesthetic sensibility; it is insight.

Artists and art-lovers generally agree that artistic perception is intuitive. It takes place, they would say, spontaneously and immediately, without reasoning, without benefit of logic. Some would claim, furthermore, that a special power of intuition leads the art connoisseur to knowledge of an inner reality, which the philistine can never know. This knowledge, they say, comes through feeling, not thought; it is irrational; it is a metaphysical contact with the real.

If you grant that artistic perception is an act of intuition, you do throw the doors wide open to this sort of mysticism, mixed with every degree of philosophical irrationalism and transcendentalism on the one hand, and on the other with sheer sentimentality and romantic fancies. But the fact that an important concept has been used in confused or questionable ways does not prevent anyone from using it properly. It merely saddles the careful user with the rather heavy task of clearing away the adventitious meanings that cling to it, and their equally irrelevant implications. "Intuition" is such an overloaded concept; and since I do believe, with many aestheticians and most artists, that artistic perception is intuitive, a matter of direct insight and not a product of discursive thinking, it behoves me, I suppose, to explain what I mean by "intuition," and especially what I do not mean. For I do not believe that artistic perception is a kind of reasoning performed, as people say, "through feeling," as though one could use feeling in place of thought to vindicate a belief. It does not involve belief, nor lead to the acceptance of any proposition at all. But neither is it irrational, a special talent for making a mystical, unnegotiated contact with reality. I submit that it is an act of understanding, mediated by a single symbol, which is the created visual, poetic, musical, or other aesthetic impression—the apparition that results from the artist's work.

What, then, is meant by calling artistic perception "intuitive"? What is meant by "intuition"?

There are, in the main, two common uses of the word in serious philosophical literature, besides its technical use as a translation of Kant's word *Anschauung*, which

we may omit here (some other words of his, sometimes translated as "intuition," fall under one of the two uses just mentioned). The first of these uses makes "intuition" mean some sort of *extra-sensory* as well as unreasoned awareness of fact—a knowledge that occurs without any mediating information, exhibition, or other experience to induce it. Katherine Wild, the author of a study entitled *Intuition,*[1] follows this first usage; she offers two alternative definitions, which in fact alternate cheerfully and indiscriminately all through her book:

"A. An intuition is an immediate awareness by a subject, of some particular entity, without such aid from the senses or from reason as would account for that awareness.

B. Intuition is a method by which a subject becomes aware of an entity without such aid from the senses or from reason as would account for such awareness."

Here the author adds a gloss: "In both cases, 'entity' is used in its widest possible significance so as to include: idea, fact, situation, indeed any one individual particular of any nature whatever. . . ."

Whether such extra-sensory and otherwise uncaused knowledge of any "entity" ever occurs seems to me highly problematical. As for the second definition, which makes "intuition" a *method* of extra-sensory and unaccountable knowing, I am quite sure no such method exists. Let us take the better definition to establish this concept of intuition: it is, then, some super-sensible and irrational awareness of what she calls "individual particulars"—things, facts, or what not, but always concrete entities.

[1] London: Cambridge University Press, 1938.

"Intuition" in this sense is a mysterious event, a startling experience when, or rather if, it occurs. Its possession is regarded as a special gift, said to be found most frequently in persons of slight or untrained discursive intellect. It is, moreover, intuition in this sense that is opposed to everything that may be called reason—observation, memory, proof, probable inference. And it is in this sense that people argue about its existence, and adduce wonderful instances to prove it or invent *ad hoc* explanations to disprove it.

There is, however, another sense of the word, that does not make intuition a dubious abnormal phenomenon, nor commit us to any denial of sensory aids or symbolic media in connection with it. This sense has been defined quite broadly and at the same time precisely by C. A. Ewing in his lecture to the British Academy, 1941, entitled "Reason and Intuition,"[2] as "cognitions that are both non-empirical and immediate." Intuition in this sense is a normal and in fact ubiquitous phenomenon in our mental life. In his later development of the subject I think Mr. Ewing tends to confuse "intuition" with "belief," which is not the same thing (we shall return to the distinction a little later). This confusion leads him to speak of religious and moral intuitions, and of erroneous claims to intuitive knowledge. I don't think there are any peculiarly religious, moral, or other topically specialized intuitions, though intuition occurs in thinking on these special topics. But that problem need not detain us. In the early part of his lecture he explains

[2] Published in the *Proceedings of the British Academy*, Vol. XXVII, and reprinted as a monograph by Humphrey Milford, London, 1941. See p. 12.

how "cognitions that are both non-empirical and immediate" occur in reasoning itself, and in so doing he is using precisely the concept here in question. Here are his words:

"In order to establish conclusions of any sort by reasoning we need premises which are supplied either by experience or by immediate insight as opposed to reasoning. . . . There is a further point of still greater importance. In order to conduct a valid deductive argument we must see that each step in the argument follows logically from the preceding one. . . . We could not start at all in any reasoning without assuming that we immediately perceive a connexion between certain premisses and their conclusion. To argue at all we must see the connexion between the propositions which constitute the different stages of the argument not by mediate reasoning but intuitively. We can no doubt call this not 'intuition' but 'immediate,' as opposed to mediate, reasoning . . . but such *immediate* reasoning would only be another name for what is commonly called intuition. The connexion between p and q would still be something that you could not *prove* but either saw or did not see."

This sense of the word "intuition" is certainly quite different from the one which Katherine Wild defined. If hers is taken as the extreme metaphysical sense, namely direct awareness of concrete reality, Mr. Ewing's use in the passage just quoted—"cognitions that are both non-empirical and immediate"—may be regarded as the other extreme, the barest, most naturalistic, and least hypothetical sense. Between these two widely different

concepts lies a whole gamut of more or less logical, more or less mystical notions (including Croce's, which makes intuition identical with expression).

Insight into the nature of relations whereby we recognize distinctions and identities, contradictions and entailments, and *use*, even if we never explicitly assert, the laws of logic, is what John Locke, in his *Essay on Human Understanding*, called "natural light." "For," he says, "in this the mind is at no pains of proving or examining, but perceives the truth, as the eye doth light, only by being directed toward it. Thus the mind perceives, that white is not black, that a circle is not a triangle, that three are more than two, and equal to one and two. Such kind of truths the mind perceives at the first sight of the ideas together, by bare intuition, without the intervention of any other idea." Locke held, furthermore, that we have intuitive knowledge of our own existence; but I am fairly sure that this special intuition, which seems, offhand, to go beyond "natural light," resolves itself upon analysis into a complex of other intuitions. Let us lay it aside for the moment, especially as it belongs to the most questionable part of Locke's doctrine, his psychology.

If, then, we gather together all the functions of intuition enumerated at various points in the *Essay*, we find that intuitive knowledge is essentially:

A. Perception of relations in general.
B. Perception of forms, or abstractive seeing.
C. Perception of significance, or meaning.
D. Perception of examples.

Each one of these intuitive functions is, of course, a meet subject for a long study; but even without further inquiry we may observe a common characteristic of all forms of insight that compose the spectrum of Locke's "natural light": *they are all either logical or semantical.* Intuition, for Locke, is not a revelation of metaphysical reality; such reality, which is called "substance" or "real essence," neither reason nor intuition finally reveals. If we have any inkling of it at all, we have it by inference from the data of "sensation and reflection."

Locke took the same view of discursive reason that Mr. Ewing presented in the passage I have quoted. Reason is a systematic means of getting from one intuition to another, of eliciting complex and cumulative intuitions. There is, then, no possible conflict between intuition as he conceives it, and discursive reason. There is a distinction between insight achieved by reasoning and insight immediately enjoyed, but that is no opposition between two radically different powers of the mind.

What I mean by intuition is essentially what Locke called "natural light" (with, possibly, some reservation about intuitive self-knowledge). Intuition is, I think, the fundamental intellectual activity, which produces logical or semantical understanding. It comprises all acts of insight or recognition of formal properties, of relations, of significance, and of abstraction and exemplification. It is more primitive than *belief*, which is true or false. Intuition is not true or false, but simply present. We may construct true or false propositions involving its deliverances, just as direct sensory experiences may be involved in true or false propositions. But that is a large

epistemological topic which we need not pursue here.[8]

Let us return to the realm of art, and to the recognition of expressiveness in works of art, and the perception of artistic import.

Such perception is, I think, intuitive. The import of a work of art—its essential, or artistic, import—can never be stated in discursive language. A work of art is an expressive form, and therefore a symbol, but not a symbol which points beyond itself so that one's thought passes on to the concept symbolized. The idea remains bound up in the form that makes it conceivable. That is why I do not call the conveyed, or rather presented, idea the *meaning* of the sensuous form, but use the philosophically less committal word "import" to denote what that sensuous form, the work of art, expresses.

The act of intuition whereby we recognize the idea of "felt life" embodied in a good work of art is the same sort of insight that makes language more than a stream of little squeaks or an arabesque of serried inkspots. The great differences between artistic import and meaning in a strict sense, lie in the disparity of the symbolic modes to which, respectively, they belong. Language is a *symbolism:* that is, a system of symbols governed by conventions of use, separately or in combination. It has the further characteristic that different complexes of its basic symbols are equivalent to each other; that is, different combinations and permutations of words (the basic symbols) may be used to express the same mean-

[8] Any reader who wishes to pursue the subject further is referred to the essay, "Abstraction in Science and Abstraction in Art," in the Appendix.

ing. This makes definition and explanation possible within the frame of language itself. It also allows us to pass from one expression to another and build up an idea out of simpler ideas gradually meted out. This process is known as discourse. Discursive thought is a passage from one intuition, or act of understanding, to another. If, at any point, intuition fails, we use equivalent symbols to present the desired meaning until insight occurs.

A work of art, though it may be called a symbol (perhaps for want of a more accurate word), is not a product of a *symbolism*, or conventional system of symbols. There are, of course, conventions in art, but these are not simply accepted conventions of symbol-using. What they are cannot well be brought into this discussion, as it would take us too far afield. The relevant facts are (1) that a picture, a statue, a building, a poem or novel or play, or a musical composition, is a single symbol of complex vital and emotive import; (2) that there are no conventional meaningful units which compose that symbol, and build up its import stepwise for the percipient; (3) that artistic perception, therefore, always starts with an intuition of total import, and increases by contemplation as the expressive articulations of the form become apparent; (4) that the import of an art symbol cannot be paraphrased in discourse.

All symbolic expression involves a formulation of what is expressed; that means recognition of form, the elementary act of abstraction, which is one of the major functions of intuition. In discourse we achieve abstraction, or awareness of form, through generalization (this again is a subject we have to eschew for lack

of time). But in art we do not generalize. A work of art is a single, specific presentation of its import. If that import is to be perceived the abstraction of it must be made directly by the way it is presented. That is why, in one way, all good art is abstract, and in another way it is concrete. The "Idea," as Flaubert called it, is not only perceived by one initial intuition, but also without being separated from its symbol; it is *universalium in re*.

The point I want to stress is that the same sort of intuition that enters into ordinary understanding, and forms the basis of discursive reason, functions as artistic perception when we are confronted with a work of art that has import for us. The great difference between rational insight and artistic insight lies in the ways intuition is elicited. We need not postulate any mysterious factor in the mind or in the world to admit that artistic perception is directly intuitive, incommunicable, yet rational: it is one of the major forms of "natural light."

The recognition of art as both a product and an instrument of human insight opens a new approach to a problem that many philosophical and psychological theories (e.g., the pleasure theory, the play theory, the "wish-fulfilment" theory) notoriously fail to meet: the problem of its cultural importance. Why is it so apt to be the vanguard of cultural advance, as it was in Egypt, in Greece, in Christian Europe (think of Gregorian music and Gothic architecture), in Renaissance Italy— not to speculate about ancient cavemen, whose art is all that we know of them? One thinks of culture as economic increase, social organization, the gradual ascend-

ancy of rational thinking and scientific control of nature over superstitious imagination and magical practices. But art is not practical; it is neither philosophy nor science; it is not religion, morality, nor even social comment (as many drama critics take comedy to be). What does it contribute to culture that could be of major importance?

It merely presents forms—sometimes intangible forms —to *imagination.* Its direct appeal is to imagination—that faculty, or function, that Lord Bacon considered the chief stumbling block in the way of reason, and that enlightened writers like Stuart Chase never tire of condemning as the source of all nonsense and bizarre erroneous beliefs. And so it is; but it is also the source of all insight and true beliefs. Imagination is probably the oldest mental trait that is typically human—older than discursive reason; it is probably the common source of dream, reason, religion, and all true general observation. It is this primitive human power—imagination—that engenders the arts and is in turn directly affected by their products.

Somewhere at the animalian starting line of human evolution lie the beginnings of that supreme instrument of the mind, language. We think of it as a device for communication among the members of a society. But communication is only one, and perhaps not even the first, of its functions. The first thing it does is to break up what William James called the "blooming, buzzing confusion" of sense perception into units and groups, events and chains of events—things and relations, causes and effects. All these patterns are imposed on our experience

70

by language. We think, as we speak, in terms of objects and their relations.

But the process of breaking up our sense experience in this way, making reality conceivable, memorable, sometimes even predictable, is a process of imagination. Primitive conception is imagination. Language and imagination grow up together in a reciprocal tutelage.

What discursive symbolism—language in its literal use —does for our awareness of things about us and our own relation to them, the arts do for our awareness of subjective reality, feeling and emotion; they give inward experiences form and thus make them conceivable. The only way we can really envisage vital movement, the stirring and growth and passage of emotion, and ultimately the whole direct sense of human life, is in artistic terms. A musical person thinks of emotions musically. They cannot be discursively talked about above a very general level. But they may none the less be known—objectively set forth, publicly known—and there is nothing necessarily confused or formless about emotions.

As soon as the natural forms of subjective experience are abstracted to the point of symbolic presentation, we can use those forms to *imagine* feeling and understand its nature. Self-knowledge, insight into all phases of life and mind, springs from artistic imagination. That is the cognitive value of the arts.

But their influence on human life goes deeper than the intellectual level. As language actually gives form to our sense-experience, grouping our impressions around those things which have names, and fitting sensations to the qualities that have adjectival names, and so on, the arts

71

we live with—our picture books and stories and the music we hear—actually form our emotive experience. Every generation has its styles of feeling. One age shudders and blushes and faints, another swaggers, still another is god-like in a universal indifference. These styles in actual emotion are not insincere. They are largely unconscious —determined by many social causes, but *shaped* by artists, usually popular artists of the screen, the juke-box, the shop window, and the picture magazine. (That, rather than incitement to crime, is my objection to the comics.) Irwin Edman remarks in one of his books that our emotions are largely Shakespeare's poetry.

This influence of art on life gives us an indication why a period of efflorescence in the arts is apt to lead a cultural advance: it formulates a new way of feeling, and that is the beginning of a cultural age. It suggests another matter for reflection, too: that a wide neglect of artistic education is a neglect in the education of feeling. Most people are so imbued with the idea that feeling is a form-less total organic excitement in human beings as in animals, that the idea of educating feeling, developing its scope and quality, seems odd to them, if not absurd. It is really, I think, at the very heart of personal education.

There is one other function of the arts that benefits not so much the advance of culture as its stabilization; an influence on individual lives. This function is the converse and complement of the objectification of feeling, the driving force of creation in art: it is the education of vision that we receive in seeing, hearing, reading works of art—the development of the artist's eye, that assimilates ordinary sights (or sounds, motions, or events) to inward

vision, and lends expressiveness and emotional import to the world. Wherever art takes a motif from actuality—a flowering branch, a bit of landscape, a historic event or a personal memory, any model or theme from life—it transforms it into a piece of imagination, and imbues its image with artistic vitality. The result is an impregnation of ordinary reality with the significance of created form. This is the *subjectification of nature*, that makes reality itself a symbol of life and feeling.

I cannot say much about this last point because I am just working with the idea myself. One of my students gave it to me, in a criticism of my own theory. But it seems to me to be of great significance.

Let us sum up briefly, then, why the arts, which many people regard as a cultural frill, are actually never a late addition to civilized life, an ornament gracing society like tea ceremonies or etiquette, but are born during the rise and the primitive phases of cultures, and often outrun all other developments in achieving mature character and technical competence. Cultures begin with the development of personal and social and religious feeling. The great instrument of this development is art. For, (1) art makes feeling apparent, objectively given so we may reflect on it and understand it; (2) the practice and familiar knowledge of any art provides forms for actual feeling to take, as language provides forms for sensory experience and factual observation; and (3) art is the education of the senses to see nature in expressive form. Thereby the actual world becomes in some measure symbolic of feeling (without being "anthropomorphized," supposed to *have* feelings) and personally significant.

The arts objectify subjective reality, and subjectify outward experience of nature. Art education is the education of feeling, and a society that neglects it gives itself up to formless emotion. Bad art is corruption of feeling. This is a large factor in the irrationalism which dictators and demagogues exploit.

6

DECEPTIVE ANALOGIES: SPECIOUS AND REAL RELATIONSHIPS AMONG THE ARTS

THE interrelations among all the arts—painting, sculpture, and architecture, music, poetry, drama, fiction, dance, film, and any others you may admit—have become a venerable old topic in aesthetics. The prevailing doctrines about those relations, too, are rapidly getting gray hair or something that looks a lot like a mould. It has lately become acceptable again to assert that all the arts are really just one "Art" with a capital *A*; that the apparent difference between painting and poetry, for instance, are superficial, due only to the difference of their materials. One artist paints with pigments, the other with words—or one speaks in rhyme, and one in images—and so forth. Dance is the language of gesture, drama is "really" a dithyramb, i.e., a choric dance, architecture is (of course) frozen music. Some aestheticians merely mark the fundamental

unity of all the arts, and then proceed to classify the various manifestations of art as lower and higher forms, major and minor arts. Thomas Munro lists a hundred kinds—alphabetically. Their peculiar differences, usually conceived as different limitations, are supposed to spring from the materials with which they work. Other philosophers and critics connect them in parallel rather than in an ascending order. These writers see a commonwealth of art, instead of a hierarchy of the arts. But all are agreed that the several arts are just so many aspects of one and the same human adventure, and almost every recent book in aesthetics begins with the statement that the customary distinctions among the arts are an unfortunate result of our modern tendency to departmentalize the contents of our lives.[1]

It is true that questions of the exact compass of this or that art—poetry, music, drama, dance—are taken more seriously in the modern age than they were in times past. Scholars like Paul Cristeller have established that fact, I think, beyond doubt. Yet we have utterances by Leonardo da Vinci and Michelangelo on the relative merits of painting, poetry, and sculpture, and comparisons of painting with music; and such comparisons go back to Horace, Simonides, and Aristotle.

Whether the distinction of the arts be old or new in aesthetic theory, in practice it is ancient. Praxiteles was a sculptor and Sophocles a poet; the statues of Praxiteles are no more likely to be confused with Sophoclean tragedies than Brancusi's statues with plays by Pirandello,

[1] See, for example, Curt Sachs: *The Commonwealth of Art.*

nor did Homer slip from epic composition into composing vases or figurines of clay. Poetry and the plastic arts have always been separate, even when poetry furnished the themes of painting and statuary, or poets mentioned the pictorial decorations on a hero's shield.

Yet the fact that all artistic activities are related to each other has always been just as apparent as their distinct characters. It is these relations which, for all that has been written about them, have so far been treated only in a superficial fashion. Sometimes we hear of *the* interrelation of all the arts. Before long this one universal interrelation is described either as an original identity or as an ideal ultimate union; and there the study of it ends, perhaps with a few examples of conjoined arts—poetry and music united in song, plastic art and music in dance, poetry and painting in a play with scenery, or all the arts in the operatic *Gesamtkunstwerk*. It ends much as it began, with quotations from many authorities denouncing the customary separation, but heightened by the positive advice that art schools should teach a course in music and music schools should take cognizance of the sister arts, painting, poetry, and drama.

There seems to be an inveterate tendency of our minds, perhaps abetted by idioms of our language, to treat any two things that bear some intimate relation to each other as identical. The identity of two terms, once established, is an important but not at all interesting relation. It means that one and the same thing goes by two names, and that is all. If poetry, music, painting, etc., are all just different names for the same thing, their relation to each other is

exhausted by the dictionary. But why should Art have so many names?

The answer to that question is usually that artists work with a great many materials, and as their techniques have to differ accordingly, they seem to be doing quite different things. All the arts are in essence one, but they differ in various accidents. From there on, we find ourselves on the trail of the accidents, and all interesting facts that emerge only lead further and further away from the basic unity of Art to its diversities.

The trouble with this approach to the interrelations of the arts is that it takes for granted the facts that are to be understood; but what a study takes for granted lies behind it, and hence cannot be the object of investigation that lies before it. What we begin with is not what we arrive at—discover, clarify, or demonstrate. If we start by postulating the essential sameness of the arts we shall learn no more about that sameness. We shall only skip or evade every problem that seems, offhand, to pertain to one art but not to some other, because it cannot be really a problem of Art, and so we shall forcibly limit ourselves to simple generalities that may be safely asserted (as is customary) of: "a poem, a sonata, a Raphael Madonna, a beautiful dance . . ." and so on.

My approach to the problem of interrelations among the arts has been the precise opposite: taking each art as autonomous, and asking about each in turn what it creates, what are the principles of creation in this art, what its scope and possible materials. Such a treatment shows up the differences among the several great genera of art—plastic, musical, balletic, poetic. Pursuing these differ-

ences, rather than vehemently denying their importance, one finds that they go deeper than one would expect. Each genus, for instance, creates a different kind of experience altogether; each may be said to make its own peculiar primary creation. The plastic arts create a purely visual space, music a purely audible time, dance a realm of interacting powers, etc. Each art has its own principles of constructing its final creations, or works. Each has its normal materials, such as tones for music, pigments for painting; but no art is limited to its normal materials by anything but their sufficiency for its normal creative purposes. Even when music uses spoken words or architecture enlists the paintbrush, music or architecture does not therefore wander from its own realm, the realm of its primary creation, whether the artist employs usual or unusual materials, in ordinary or extraordinary ways.

But if you trace the differences among the arts as far and as minutely as possible, there comes a point beyond which no more distinctions can be made. It is the point where the deeper structual devices—ambivalent images, intersecting forces, great rhythms and their analogues in detail, variations, congruences, in short: all the organizing devices—reveal the principles of dynamic form that we learn from nature as spontaneously as we learn language from our elders. These principles appear, in one art after another, as the guiding ones in every work that achieves organic unity, vitality of form or expressiveness, which is what we mean by the significance of art.

Where no more distinctions can be found among the several arts, there lies their unity. We need not accept this unity by faith and reject as vicious all inquiries that

79

call it in question; its demonstration is the result of such inquiries. Here we have certainly the deepest relationship among the arts: they all exemplify the general principles of Art. I am using the word "Art" in the restricted sense sometimes delimited as "the fine arts" or "liberal arts"—plastic, musical, literary, theatrical, etc.—and not in the widest sense, in which we speak of "the arts of war and peace." Both uses are current; but I am talking about the kind of Art whost products are judged as *artistic* or *inartistic*. We do not say that a bungled surgical operation is inartistic (though we may find it unaesthetic). Using "Art" in its restricted sense, then, I venture the definition: *All art is the creation of perceptible forms expressive of human feeling*.

This definition contains several weasel words: "creation," "forms," "expressive," and even "feeling." But weasels do have holes where they may be cornered. I don't think my weasels are sliding around quite freely any more; but if I were to catch them for your inspection just now we would need more than this one hour to get on with our subject, the relations that hold among all the arts or among some of them.

Essentially, then, all the arts create forms to express the life of feeling (the *life of feeling*, not the feelings an artist happens to have); and they all do it by the same basic principles. But there the simple sameness ends. When we look at what the various arts create, we come to the source of their differentiation, from which each art derives its autonomy and its problems.

Each art begets a special dimension of experience that is a special kind of image of reality. In *Feeling and Form*

I called this special dimension the "primary illusion," but "illusion" is a prejudicial word, and as we have no time to explain and justify its use here, we had better shelve it altogether. Let us call it the *primary apparition* of an art... (A brief exposition of this concept is here deleted, because it is already given in the lecture on artistic creation.)

Each one of the arts has its primary apparition, which is something created, not something found in the world and used. The materials of art—pigments, sounds, words, tones, etc.—are found and used to create forms in some virtual dimension. I call this primary apparition "primary" not because it is made first, before the work (it is not), but because it is made *always*, from the first stroke of work in any art. Everything a painter does creates and organizes—or in sad event, disorganizes—pictorial space. Where no pictorial space is created we see spots of color on a flat object, as we see them on a palette, or as we see spilled paint on the floor. But even a very bad picture is a spatial apparition.

Music, on the other hand, though it may create experiences of space, is in a completely given dimension of *virtual time*. Virtual time is its primary apparition, its dimension, in which its created forms move. I cannot go into further explanations here, but only indicate the findings of an enquiry that began by treating each art in its own terms, and became general by stepwise generalization.

Let it suffice, then, that each of the great orders of art has its own primary apparition which is the essential feature of all its works. This thesis has two consequences for

our present discussions: it means that the distinctions commonly made between the great orders—the distinction between painting and music, or poetry and music, or sculpture and dance—are not false, artificial divisions due to a modern passion for pigeonholes, but are founded on empirical and important facts; secondly, it means that there can be no hybrid works, belonging as much to one art as to another. And we might add that the evolutionist's idea of one undifferentiated Art preceding, in primitive times, the several kinds of art, loses much of its offhand plausibility.

At this point most people will be ready to ask: "But is there, then, no relation whatever among the arts, except their unity of purpose? Are they historically entirely unrelated? And do you mean to say poetry and music are never used together in song, nor sculpture and architecture in a monument? How silly!"

My answer is that to say two things are distinct is not to say they are unrelated. The fact that they are distinct is what enables them to have all sorts of highly specialized, interesting relations to each other—much more interesting than the relation of pseudo-identity that we allege when we hold them to be, really, several views of the same thing, so they might melt into each other on better inspection. It is precisely by reason of their distinct primary apparitions that such complex works as song, opera, drama, or choric dance are not just the normal functions of several arts conjoined in varying proportion. In such works there are interesting, often involved relationships that one would not suspect without the guiding

question: "What, in this case, is created? Only apparitions are created; what sort of apparition is this?"

The arts are defined by their primary apparitions, not by materials and techniques. Painted sculpture is not a joint product of sculpture and painting at all, for what is created is a sculpture, not a picture. Paint is used, but used for creating sculptural form—not for painting. The fact that poetry involves sound, the normal material of music, is not what makes it comparable to music—where it is comparable.

In fact, direct comparison is an over-rated method for discovering relations among the arts. Long before you can generalize by comparison of the actual processes involved in plastic, musical, poetic, and all other kinds of creation, and thus relate all the arts as species of one genus, (i.e. Art), the study of just two primary apparitions is enough to bring some interesting relations to light; for instance, what is the primary apparition in plastic art— virtual space—may appear as a secondary apparition in music, whose essential stuff is virtual time. There are spatial effects in music; and careful study—not fancy— shows that these are always effects of virtual, not actual, space, with the characteristics which painters and sculptors call "plastic." Similarly, where time-effects are achieved in the plastic arts, they always have the qualities of virtual time, the "stuff" of music. Progressively we find then that the primary apparition of any art may appear as secondary in another, and that in the arts generally all space is plastic space, all time is musical time, all impersonal forces are balletic (the word "balletic" here refers to Dance, not specifically ballet. There is no

English adjective equivalent to the German *tänzerisch*),
all events poetic. Everything in the arts is created, never
imported from actuality; and in this way their funda-
mental creations meet. This is one of their exchanges.

Another, more striking (though perhaps not more
important) relation between two arts obtains where a
work of one art serves in the making of another work
belonging to another art: the case in which two arts are
usually said to be conjoined. Consider, for instance, a good
poem successfully set to music. The result is a good song.
One would naturally expect the excellence of the song
to depend as much on the quality of the poem as on the
musical handling. But this is not the case. Schubert has
made beautiful songs out of great lyrics by Heine, Shake-
speare, and Goethe, and equally beautiful songs out of
the commonplace, sometimes maudlin lyrics of Müller.
The poetic creation counts only indirectly in a song, in
exciting the composer to compose it. After that, the poem
as a work of art is broken up. Its words, sound and sense
alike, its phrases, its images, all become musical material.
In a well-wrought song the text is swallowed, hide and
hair. That does not mean that the words do not count,
that other words would have done as well; but the words
have been musically exploited, they have entered into a
new composition, and the poem as a poem has disappeared
in the song.

The same thing holds for music and dance. A dance is
not necessarily the better for using very good music.
Dance normally swallows music, as music normally swal-
lows words. The music that, perhaps, first inspires a
dance, is none the less cancelled out as art in its own right,

and assimilated to the dance; and for this many a third-rate musical piece has served as well as a significant work.

Every work has its being in only one order of art; compositions of different orders are not simply conjoined, but all except one will cease to appear as what they are. A song sung on the stage in a good play is a piece of dramatic action. If we receive it in the theatre as we would receive it in concert, the play is a pastiche, like the average revue that is not a creation at all, but a series of little creations, variously good or bad themselves.

This far-reaching principle of cross-relationships among the arts is the principle of assimilation. It sounds very radical, but I have always found it to hold. Opera is music; to be good opera it must be dramatic, but that is not to be drama. Drama, on the other hand, swallows all plastic creations that enter into its theatrical precinct, and their own pictorial, architectural, or sculptural beauties do not add themselves to its own beauty. A great work of sculpture, say the original Venus of Milo that stands in the Louvre, transported to the comic or tragic stage (perhaps in a play about a sculptor) would count only as stage setting, an element in the action, and might not meet this purpose as well as a pasteboard counterfeit of it would do.

The principle of assimilation holds usually in certain familiar ways. Music ordinarily swallows words and actions creating opera, oratorio or song; dance commonly assimilates music. But this is not a fast rule. Sometimes a poem may swallow music, or even dance; dramatic poetry quite normally does both. I have never known music to incorporate dancing, but it might. The only safe

assertion is that every work has its primary apparition, to which all other virtual dimensions are secondary. There are no happy marriages in art—only successful rape.

Half-baked theories, such as I consider the traditional theories of the unity of Art to be, are apt to have sorry consequences when practice is based on them. Among such sorry consequences are the works that result from serious efforts to paint the counterparts of symphonies or parallel poems or pictures by musical compositions. Color symphonies are painted in the belief that the deployment of colors on a canvas corresponds to the deployment of tones in music, so that an analogy of structure should produce analogous works. This is, of course, a corollary of the proposition that the various arts are distinguished by the differences in their respective materials, to which their techniques have to be adapted, but were it not for these material differences their procedures would be the same. Oddly enough, the results of such translation, when it is really technically guided, have no vestige of the artistic values of their originals. Even where the parallels of structure are recognizable, as in a painted design following the verbal design of a sonnet, the visual forms may be interesting, even pleasant, but they are not creative, beyond their mere creation of virtual space (which they do create); as expressive forms they do not resemble the sonnet at all.

There is another class of translations that purports to express in one medium the emotional values of some work in a different medium; and this sort of suggestion (it is really nothing more) tends to produce works that are very weak in form. Simonides said that architecture is

frozen music; but music is not melted architecture. When this musical ice cream is returned to its liquid state, it runs away in an amorphous flow of sound. The same weakness appears in painting that purports to render musical composition. I am thinking of the musical colors in *Fantasia*, and the music-paintings of students in the Boston Museum School of Art. A painting expressive of a very lyrical composition, such as Chopin's G major *Nocturne*, has no lyrical character at all, but only indistinct washes of color. The reason for such failure is that the painter is not guided by discernment of musical values, but is concentrating his attention on his own feelings under the influence of sounds, and producing *symptoms* of these feelings. What he registers is a sequence of essentially uncomposed, actual experiences; symptoms are not works.

There is, however, a notable exception to these failures of artistic translation. Sometimes a poet calls certain of his poems "quartets," or a composer entitles a composition "Arabesque," and the designation seems fitting, even enlightening, although it suggests no particular model nor invites any method of comparison. That is because the artist—say T. S. Eliot, in the *Four Quartets* —creates an effect, an expressive virtual entity purely poetic, that functions in some particular way characteristic of string quartets: combining great richness of feeling with extreme economy of material. The result is a semblance of concentration together with complete articulation. In the poems it is all done by means of the proportion of material to technique, and of scope of feeling to scope its image. The poems are very brief. In

quartet music it results from the complete exploitation of just four voices. A normal quartet is not very brief, but generally has four movements.

Similarly, Schumann's "Arabesque" does not copy any design of Arabic sculpture, but it achieves a feeling of elaborated thought where no thought really has beginning or end, or of motion in a maze yet without dizziness. This effect, which is characteristic of Arabesque sculpture and architecture, is rare and striking in music.

The important point in these parallels is, that they do not co-ordinate materials, for instance tones with words, or phrases with sculptured forms. Interweaving of phrases is only an obvious bit of imitation in Schumann's piece; the to and fro of ambiguous or mixed harmonies and the relations of melodic to rhythmic accents are just as important, and correspond to nothing in a stone tracery. The sculptor works with light, texture, height, and many other material data of which Schumann was certainly not thinking. He probably was not even thinking of any particular arabesque, though of course we cannot know his thought.

As such successful analogues do not rest on correspondence of material factors, so also they are not comparably constructed. The similarity that justifies the borrowed title word holds between their respective *formulations* of feeling, and these are achieved in entirely different ways in different arts. There is no rule that can govern two arts, and probably no technical device that can be taken over from one to another, let alone materials that correspond. But there are comparable created forms.

88

Such occasional parallels would be trivial, were they not further related to one of the most exciting phenomena in the realm of the arts, which may be termed "ultimate abstraction," or "transcendence."

But this is a difficult topic, inviting philosophical speculations that had better not come into a brief single lecture, especially at its weary end: I mentioned it only because it is the most interesting and perhaps the closest relation among the arts—the point where their imaginal distinctions seem really to yield, for a moment, to their community of import, and achieve the utmost abstraction of that import for the beholder's direct intuition. It is here that all art "aspires towards the condition of music," and music becomes a timeless vision of feeling.

7

IMITATION AND TRANSFORMATION IN THE ARTS

THE problem I wish to bring up for discussion today is
—like most special problems—part and parcel of a more
general topic; it presupposes a certain opinion about the
import and essential nature of art. This opinion has
grown out of previous studies, so that I can only give
you my conclusions in a statement that must sound dog-
matic, even arbitrary. I shall have to ask you to accept
them tentatively as the background of my present argu-
ment; perhaps they may come in for some discussion
later.

What we call "art" in the liberal sense does not differ
from craft, or "art" in an older sense, in matter or
technique; but it differs radically in its aim. Like any
craft, a so-called "fine art" is the manipulation of crude
matter—stone, wood, clay, pigment, metal, etc., or (by
an extension of the concept of "matter") sounds, words,
gestures, or other stuff, for the purpose of constructing

a desired object, an artefact. But, whereas most artefacts are made for an instrumental purpose, what we call a work of art is made for the ultimate purpose of achieving certain qualitative effects, which have expressive value.

What does art seek to express? (Here again, I can only state my own notions dogmatically): I think every work of art expresses, more or less purely, more or less subtly, not feelings and emotions which the artist *has*, but feelings and emotions which the artist *knows;* his *insight* into the nature of sentience, his picture of vital experience, physical and emotive and fantastic.

Such knowledge is not expressible in ordinary discourse. The reason for this ineffability is not that the ideas to be expressed are too high, too spiritual, or too anything-else, but that the forms of feeling and the forms of discursive expression are logically incommensurate, so that any exact concepts of feeling and emotion cannot be projected into the logical form of literal language. Verbal statement, which is our normal and most reliable means of communication, is almost useless for conveying knowledge about the precise character of the affective life. Crude designations like "joy," "sorrow," "fear," tell us as little about vital experience as general words like "thing," "being," or "place," tell us about the world of our perceptions. Any more precise reference to feeling is usually made by mentioning the circumstance that suggests it—"a mood of autumn evening," "a holiday feeling." The problem of logic here involved is one I cannot go into; suffice it to stay that what some people call "significant form," and others "expressiveness," "plastic value" in visual art or "seo

ondary meaning" in poetry, "creative design" or "inter-
pretation" or what you will, is the power of certain
qualitative effects to express the great forms and the rare
intricacies of the life of feeling.

Some of these seem to find direct expression in visual
and audible forms. Mr. Albert Barnes suggested that our
mental orientation in space, which gives freedom and
certainty to our perceptual powers and is the uncon-
scious pivot of our mental life, is what lends significance
to pure geometric design. Jean D'Udine, in his little
book on the relation of art and gesture, remarks on the
direct expression of vital feelings by all rhythmic forms,
whether musical or kinetic or visual. These are the simple
expressive elements of art, as names and literal assertions
are the simple expressive elements of language.

But as soon as human conception finds an adequate
symbol, it grows like Jack's beanstalk, and outgrows the
highest reaches of what seemed such an adequate form
of expression. The better the symbolism, the faster it
has to grow, to keep up with the thought it serves and
fosters. That is clearly demonstrated by language. A
child with ten words to its credit has certainly more than
ten concepts at its command, because every word lends
itself at once to generalization, transfer of meanings,
suggestion of related ideas, all sorts of subtle shades and
variations created in *use*. The same thing holds for
artistic expression. Just as language grows in subtlety,
in syntactical forms and idiom as well as in vocabulary,
so the power of articulation through sensuous form
grows with the needs of the conceiving mind.

The aim of art is *insight*, understanding of the essential

life of feeling. But all understanding requires abstraction. The abstractions which literal discourse makes are useless for this particular subject-matter, they obscure and falsify rather than communicate our ideas of vitality and sentience. Yet there is no understanding without symbolization, and no symbolization without abstraction. Anything *about* reality, that is to be expressed and conveyed, must be abstracted *from* reality. There is no sense in trying to *convey reality* pure and simple. Even experience itself cannot do that. What we understand, we conceive, and conception always involves formulation, presentation, and therefore abstraction.

Most people associate the word "abstraction" only with technical words that evoke as little imagery as possible, preferably none. But such words are always a repository of abstractions made long ago, which are now being used as common currency, chiefly by intellectual specialists who manipulate them without feeling at all excited by any new understanding they convey. The understanding of their meanings is, in fact, not new. When it was new, these words were not used for those concepts; great figures of speech were used to express our first scientific insights. Time, when it was first conceived as a scientific notion rather than a fateful Being, flowed in a one-dimensional stream from the throne of God. Space was chaos and abyss, abstracted from the rest of existence in mystic symbols, before this abstraction grew familiar enough to have a dead common-sense name and be defined by all the propositions of descriptive geometry.

How, and by whom, are abstractions originally made?

By men of profound mind in every age, by the most powerful users of language or other symbolism, who can force us to see more than the ordinary accepted meaning in familiar symbols. The abstractions of language, which govern most of our normal thinking, arise from a very fundamental, wide-spread, but little recognized phenomenon inherent in the very nature of speech—the use of *metaphor*. I shall say more about this presently.

Of course, all conceptual formulation involves some abstraction; even ordinary expression in such sentences as: "I was in New York yesterday," involve a choice of *aspects* of the situation referred to, and these alone are mentioned. A million other people were in New York yesterday, too; yet my being there differed from theirs in activity, feeling, purpose, in practically everything except the highly abstracted *fact* which I mention. Language abstracts from reality by the choice of things and states to which it gives names, such as "yesterday," "New York," and "having been," as well as persons and individual physical objects. Without our unconscious recognition of these abstracted concepts embodied in words we could not talk: every experience would have a proper name whose meaning would be indefinable, a sort of subjective memory scheme.

The arts, like language, abstract from experience certain aspects for our contemplation. But such abstractions are not concepts that have names. Discursive speech can fix definable concepts better and more exactly. Artistic expression abstracts aspects of the life of feeling which have no names, which have to be presented to sense and intuition rather than to a word-bound, note-taking con-

sciousness. Form and color, tone and tension and rhythm, contrast and softness and rest and motion are the elements that yield the symbolic forms which can convey ideas of such nameless realities. When we say that a work has a definite feeling about it, we do not mean that it either *symptomizes* this feeling, as weeping symptomizes an emotional disturbance in the weeper, nor that it stimulates us to feel a certain way. What we mean is that it presents a feeling for our contemplation.

The production of such expressive structures requires some more tangible conception than the idea which is yet inarticulate, to guide the artist's purpose. Nothing is so elusive as an unsymbolized conception. It pulsates and vanishes like the very faint stars, and inspires rather than fixes expression. So the usual anchor for such intuitions is an object in which the artist sees possibilities of the form he envisages and wants to create; and the primitive art impulse is to *imitate* natural forms which he finds expressive.

Yet the imitation, though faithful to what he sees, is never a *copy* in an ordinary sense. It is a biassed rendering, it records what he finds significant; if he is deeply absorbed in his model, the simplified or even projected version of it is exactly what he sees, and all he sees. Primitive art, which is undistracted by theories, tends to be more purely stylized and expressive than more sophisticated work; yet the earliest writers in every branch of art are naively convinced that what we call creation of forms is simply a careful, faithful process of imitation.

The imitation of objects with a difference—with the

all-important, interpretative difference—is what we call *treatment* of the object, and all treatment serves the purpose of making those sensuous abstractions which constitute artistic significance. The model for the picture, the statue, or the epic gives the work its theme, but not its meaning; the *treatment* of the theme is the articulation of a form that has an import of its own.

All technique is developed in the interest of treatment; and as treatment is simply the mode of imitation, and a truly absorbed and active artist may be quite unconscious of the mode he is evolving, all naive technicians have taken for granted that their devices were merely modes of imitation. So the great life-line of technique has been imitation, as its origin has been formalization. Technique is the power of producing a version of the model, as concrete as real existence—a vision of existence, a realization of things in the world. Its aim is always a definite sensuous or emotional *effect*, which is to be brought to perception.

In the achievement of *effects* lies the abstractive function of art. The effect is sought because it conveys the insight into human feeling that is, I think, the aim of all art. Therefore technique is the skill of getting effects; and in every art we develop traditional means of "imitation" to enhance certain effects that artists see in the model and convey to those who can perceive through art. Such traditional means are what we call "conventions." They are not "laws," for there is no reason in the world to follow them except that the artist can use them for his own purposes. When their usefulness is

exhausted, they are dropped. That is why conventions change.

The most obvious conventions of imitation are such devices as local color, darkened for shadow; bending trees and streaming hair to indicate wind, and unstable attitudes to suggest bodily action. This last device is applicable to sculpture, too, although sculpture is extremely sensitive to imitative practices such as painting statues or even mixing different materials for realistic effects.

The imitative stunts of program music, from the cuckoo in a 12th century song to the nightingale on Respighi's phonograph plate, have received too much attention to require further introduction. In the modern dance, which undertakes to be more than a simple pattern of so-called "steps," the choreographer naturally looks to that world-old guide to artistic creation, the imitation of nature, and employs all such obvious helps as impersonation, costume, and above all, pantomime. Running, pursuing, evading, falling, ritual gestures, and gesticulations are the stock-in-trade of the art-ballet. In dramatic art, imitation reaches its height, especially with the advent of the social drama and all its realistic relatives. A play like "The Bellamy Trial" practically takes the onlooker into an ordinary court-room to witness an almost unabridged judicial scene. Costumes, properties, gestures, speeches are at their maximum of direct imitation. Such facts as that the room lacks a wall and that the light is somewhat exaggerated actually threaten to come into consciousness against such faithful realism. Speech imitations are prominent in the novel,

too; and beyond them we have that imitation of actual thought-processes known as the "stream-of-conscious-ness technique."

Almost every technical advance is first felt to be the discovery of a better means of imitation, and only later is recognized as a new form, a stylistic convention. And the more the mode of presentation is conditioned by the artist's conception, by the effect he desires rather than by the scientific properties of the model, the more readily it is accepted as "true" by the imagination.

This brings me to the special cases where technique, devoted to imitation for the attainment of emotively significant effects, transcends imitation altogether, and achieves the effect, so to speak, in abstraction. This extreme type of treatment might be designated as *transformation** rather than imitation; it consists in the rendering of a desired appearance without any actual representation of it, by the production of an *equivalent* sense-impression rather than a literally similar one, in terms of the limited, legitimate material which cannot naively copy the desired property of the model. To render the effect of a sound without actual imitation of it; to convey a sense of motion by dynamic lines, without picturing attitudes or events that connote it; to convey a dramatic situation by well-timed silences instead of exciting statements; such practices involve a *transformation* of the idea furnished by the model (be the model a thing, an event, or a character), into the

* I have spoken of it elsewhere (see p. 89) as "transcendence," but found that this term too often aroused an expectation of some ultimate mystical doctrine.

plastic material of which the work is made. To get a spatial effect through a medium of sound, or a sense of pure light—of dazzle of glitter or radiance—by means of color or form, without any special illumination— that is what I mean by *transforming* the appearance of the model into sensory structures of another sort.

Examples may be found in all fields of art. The very example I just mentioned—conveying light-effects through a medium which cannot directly copy light—is cited by Ching Hao, a Chinese theorist of the tenth century: "The master of Ink can heighten or lower his tone at will, to express the depth or shallowness of things; creating what seems like a natural brilliancy, not derived from the line-work of the brush." (Note that dark and bright themselves express depth and shallowness *of things*.) And just before this, in speaking of "Harmony," by which he appears to mean Composition, he says: "Harmony, without visible contours, suggests form; omits nothing, yet escapes vulgarity." To convey form by a device other than outline, yet in terms of ink, is that subtle achievement of effects I call "transformation."

In sculpture, the power of translating impressions of many senses into purely sculptural terms is of paramount importance, because of the great sensitivity of its forms to any illegitimate use. Walter Pater has left us a critical essay exactly to this point, in his well-known little book on the Renaissance, where he says, a propos of Della Robbia's work: "These Tuscan sculptors of the 15th century worked for the most part in low relief. ... This system of low relief is the means by which they

meet and overcome the special limitation of sculpture—a limitation resulting from the material and the essential conditions of all sculptured work, and which consists in the tendency of this work to a hard realism, a one-sided presentment of mere form, that solid material which only motion can relieve, a thing of heavy shadows, and an individuality of expression pushed to caricature. Against this tendency to the hard presentment of mere form trying vainly to compete with the reality of nature itself, all noble sculpture constantly struggles: each great system of sculpture resisting it in its own way. . . . The use of colour in sculpture is but an unskilful contrivance to effect, by borrowing from another art, what the nobler sculpture effects by strictly appropriate means. To get not colour, but the equivalent of colour; to secure the expression and the play of life; to expand the too fixed individuality of pure, unrelieved, uncoloured form—this is the problem. . . ." And elsewhere he says of Michelangelo: "In a way quite personal and peculiar to himself which often is, and always seems, the effect of accident, he secured for his work individuality and intensity of expression, while he avoided a too hard realism, that tendency to harden into caricature which the representation of feeling in sculpture must always have. What time and accident, its centuries of darkness under the furrows of the 'little Melian farm,' have done with singular felicity of touch for the Venus of Melos, fraying its surface and softening its lines, . . . this effect Michelangelo gains by leaving nearly all his sculpture in a puzzling sort of incompleteness, which suggests rather than realizes actual form. . . . That in-

completeness is Michelangelo's equivalent for colour in sculpture; it is his way of etherealizing pure form, of relieving its hard realism, and communicating to it breath, pulsation, the effect of life."

There is a very striking case of sensuous transformation in the poetry of Keats. It is a line from his "Ode to a Nightingale," which is sometimes cited as an example of onomatopoiea, an imitation of the nightingale's song:

> "Now more than ever seems it rich to die,
> To cease upon the midnight with no pain,
> While thou art *pouring forth thy soul abroad*
> In such an ecstasy!"

Oddly enough, when we consider the onomatopoetic line—"pouring forth thy soul abroad"—there is no imitation of a bird's song at all; no bird ever uttered the "o" sound on which the alleged imitation is based. "O" is about the last vowel sound that a bird's song could ever approach. What is the quality conveyed by that line, that assimilates it to the nightingale's song? It is the *intensification of sound* achieved here by the piling of the successive open o's, and in the bird's song by a characteristic crescendo. But note that not even the crescendo is actually *imitated;* the end of the line need not be spoken *louder* than the beginning; the sound-pattern itself yields the *intensification* that is the essence of the swelling song. This is, I think, the most perfectly successful transformation of musical sound into verbal quality, that I know. It seems to me far more effective than the consciously imitative "word-music" of Swinburne, which achieves a liquid rather than a strong musical effect. (I suspect that he wanted it to be "liquid,"

and that the "musical" aim is something taken for granted by critics because it is familiar in the literature of poetics.)

The "imitations" of music itself have so long been a subject of debate that we need not discuss the conventions that have grown up for the rendering of rippling water, horses' hooves, winds and undulating seas and tolling bells. So long as the suggestive devices are entirely in the realm of music, perfectly comprehensible and complete without the program, the alleged or perhaps avowed imitation serves the same purpose here as in any other art—it offers a *musical theme*, and nothing more. I don't see that this is worth a quarrel. When, however, special sounds are admitted, not for their intimate relation to the other elements of the work, which logically develop toward such an effect, but for the sake of programme-interest (like the inevitable castagnettes in representations of Spanish festivity), or when the musical structure is violated or obscured by a lot of literary meanings, imitation is a vice. There is no musical treatment of themes in the imitations rendered by a wind-machine or a phonograph-plate. But treatment is the essence of art. Even frank imitation, in the limited materials of an art, is always formalization. Schubert's brooks weave purely musical figures, his larks sing genuine tunes that ring in one's head like free melodies —like all of Schubert. Yet his accompaniments *are* programmatic; they imitate cradle and riding rhythms, sobs, hunting-horns, proud ascents, and sinkings to the grave. The theme is the skeleton of the piece; but living form,

the musical rendering, is with such a difference that now it is *Schubert's* brook, it is *Schubert's* post-horn.

So even in music we may have legitimate imitation, notably in the genre known as the German "Lied." And such imitation may degenerate into literalism, or rise to the more difficult and subtle devices of transformation. There is a fine instance of this higher technique, in Brahms's song, "The Smith." The accompaniment of this song elucidates the subject, with a motif of grace-notes blurring staccato chords much as the rebound of the hammer blurs the ringing stroke. This is frank imitation. But oddly enough, the vocal part alone conveys the exciting metallic clang, without any patent reproduction of the characteristic smithy sounds; and when you analyse the effect, it is due to the hard, perfect intervals and extreme use of contrary motion. The tones themselves are not metallic; the three-quarter rhythm, often contradicted by a two-fourth melodic rhythm, is not a copy; but something proper to the subject is rendered in that melody. This is a genuine *transformation* of occupational noise into purely musical elements—not a quality of tones similar to the noise, but *relational* effects that belong inherently to harmonic intervals and melodic progressions.

Once upon a time, in supervising a very young violinist's practice, I asked him whether he knew which form of the minor scale was called the "melodic minor." After a moment's thought, he replied, "Oh, yes, that's the one that asks you a question going up, and tells you the answer coming down." Now the melodic minor is no more an imitation of rising voice-inflection than any

other ascending scale; the questioning tone does not present anything like the raised steps in that mode; but the *tension* they create, which is promptly resolved by the normal form of the descent, symbolized for that child the tension and resolution of question and answer, suspense and release. This is the material for a musical transformation.

Whenever a feeling is conveyed by such an indirect rendering, it marks a height of artistic expression. Among the forthright and familiar conventions of imitation, a sensuous transformation acts much as a strong metaphor does among the well-understood conventions of literal speech: its feeling is more poignant and its meaning more impressive than the import of ordinary communication. It conveys a summation and an essence. Why?

For the same reason that a metaphor is apt to be more revealing than a literal statement. So let me stop briefly to consider the function of metaphor, because it is more familiar, more common, and more obvious than the phenomenon I have spoken of as "transformation" in art. In the history of language, in the growth of human understanding, the principle of metaphorical expression plays a vastly greater role than most people realize. For it is the natural instrument of our greatest mental achievement—abstract thinking.

At first blush it may appear as a paradox that metaphor, which enriches poetry and prophecy with concrete imagery, should be an instrument of abstraction. Yet that is its true nature; it *makes us conceive* things in abstraction; the bloodless abstract language we usually

associate with abstract ideas only *names* them after they have long been conceived, and have grown familiar.

An idea which is genuinely new, a thing noted for the first time, has no name. There is no word to express it. How can it be pointed out or mentioned for the first time?

The normal way of expressing such a conception is to seek something which is a natural symbol for it, and use the name of the symbol to "mean" the new idea. An example of this may be seen in the primitive expressions for the notion of a disembodied life or personality—spirit, ghost, *anima*. They are words which originally denote *breath, shadow,* or some other physical phenomenon which is perceivable but intangible. Its intangibility makes it a natural symbol for the concept of an existence which is actually imperceptible, non-physical. When we use a word for breath to mean the element of life, we use it metaphorically, just as when we use words like "brilliance," "enlightenment," and other expressions literally referring to light, to denote intelligence. Originally these are all metaphors directly conveying an image; and it is the image that expresses the new insight, the nameless idea that is meant. The image, the thing actually named, is the literal meaning of the word; the metaphorical sense is the new concept which (when it is first encountered) no word in the existing vocabulary literally denotes.

The power of abstraction is an essential human trait. If many images, each of which naturally symbolizes a certain idea, are brought together, this common significance shines forth more and more clearly, like the one

meaning of Pharaoh's three dreams. Gradually the meaning can be grasped apart from its many concrete embodiments; that is the process of abstraction. But by the time such an indirectly known meaning receives a name of its own, it is no longer a new idea; it is familiar, and therefore prosaic. Its conventional name is an abstract word.

The meanings which pure visual forms (apart from their practical significance) and musical patterns convey are nameless because they are logically uncongenial to the structure of language. They will presumably never have literal handles. So their very life, for our consciousness, is in their artistic embodiments. For the artist, these vital meanings are naturally expressed in his model; in his *treatment* of the model they are emphasized and clarified. That is the logic of his "style." The *effects* he creates are those sensuous experiences which are wordless, unanalyzable symbols for the life of feeling.

Now, a technique of imitation is a means of recreating those aspects of the object in which the artist finds emotive meaning; it is therefore the normal practice of representative art, as direct denotation is the normal practice of speech. But when the significant aspect of the model—the crescendo of the nightingale's song, the warm color of flesh—is itself indirectly rendered by a device that abstracts only its significance without copying it directly, that is, when it is *transformed* into properties of words or of marble, its artistic value shines forth like the intuitively perceived meaning of a metaphor in language—something beyond the expressive medium, stripped of its accidental embodiment by having more

than one expression. Hence its heightened import, its poignancy and subtlety. It underlines the abstractive power of art—the "significance" which Clive Bell refers to in his rather cryptic notion of "significant form," the thing which Coleridge called "secondary meaning," and Flaubert called the "idea" of a work. It is, I think, the quintessence which so-called "abstract art" seeks to convey, and which the non-imitative arts have always expressed: the morphology of vital and emotive experience. Art is the articulation, not the stimulation or catharsis, of feeling; and the height of technique is simply the highest power of this sensuous revelation and wordless abstraction.

8

PRINCIPLES OF ART AND
CREATIVE DEVICES

It has often enough been remarked that the concept of art changes from age to age; that different nations, different epochs, even different schools within one time and place, have different notions of what art is, and therefore different judgments of what is or is not art; and that consequently no one can say, once and for all, what art is, what is meant by the term "a work of art," nor what is or is not to pass for such a work.

If these sweeping statements were true there would be little point in either criticizing and teaching art, or in philosophizing about it (or even producing it). But they are almost all too sweeping to be true, or, for that matter, to be false.

Let us begin with the first statement: that the concept of art changes from age to age. How to we determine what is, in any age, the concept of art? There are, for most ages, two main sources of information: what

theorists in a given time say about art, and what the artists of that time seem to assume. The same goes, of course, for different places at any time, for instance Greece, Egypt, and China in 600 B.C., or France and Russia in 1950 A.D.

It is possible, I think, to formulate a definition of art that applies to everything artists have made, and made with varying success. That means that the concept of art implicit in practice—that is, "what the artists seem to assume"—does not vary from age to age and from place to place. I think it is safe to say that all art is the creation of "expressive forms," or *apparent forms expressive of human feeling*. That definition applies to the primitive "Venuses" and the Venus of Milo and Brancusi's "Bird," and to the Psalms of David and Herrick's "Fair Daffodils" and Joyce's *Ulysses*, to *Sakuntala* and *Tartuffe* and *The Emperor Jones* and *The Play's the Thing*, and to the famous cave paintings and the polite portraits that Reynolds and Sargent painted, and to ancient temple chants and African drum music and Mozart and Wagner. It defines, I think, what all artists have always done. There is little gained by calling "art" only what we judge to be good. Some art is bad; also, a work may be unsuccessful, or rather poor. But where there is any artistic intent (whether avowed, exclusive artistic intent, or unconscious artistic impulse) there will be some artistic result, i.e., some expressive form. The main point is that this definition includes every *kind* of art. Whether a work is good or bad depends on other things than the artistic intent. But whether it is art depends on its maker's desire to compose it into a form

that expresses his idea of a feeling or a whole nexus of feeling—or, as he would be likely to say, "that has some feeling in it," or "has life."

Yet this broad definition excludes some things that theorists have sometimes included in the category of "works of art." Irwin Edman defined art as "the realm of all controlled treatment of material, practical or other." He was, of course, in good company; Plato spoke of catering, shoemaking, and medicine as "arts," and called business "the art of payment." But in Plato's discourses the word was clearly understood in two senses. When Aristotle classified the arts as "perfect" and "imperfect" he assumed the distinction which we make by the clumsy term "fine arts" for the arts he meant. Edman, however, explicitly denied the distinction. He said, in *Arts and the Man*, "It is for purely accidental reasons that the fine arts have been singled out to be almost identical with Art. For in painting and sculpture, music and poetry, there is so nice and so explicit a utilization of materials . . . that we turn to examples of these arts for Art and in them find our aesthetic experience most intense and pure."

Actually, the sensory or literally "aesthetic" experience of perfectly used materials is perhaps keenest in our appreciation of food and drink. Edman had too much artistic sense to draw his own conclusions, but they have been drawn; Baker Brownell in *The Seven Lively Arts* includes cooking, and Willem Thieme makes cooking and philosophy the lowest and highest stations, respectively, in the gamut of the arts. John Dewey unconfused by Albert Barnes might have ranged ballet and golf, and sculpture and hairdressing, all on a par;

I don't know, since in fact he was influenced—enlightened, but also deeply confused—by Barnes.

My reason for rejecting the definition of art as all craft is pragmatic. Directors of art museums would go crazy if they had to exhibit the pies and jellies that win prizes at country fairs, and the nylons and dishmops and cigarettes that are definitely superior to anything else in the world. You can't use such a broad definition in museology. Secondly, foundations that sponsor the arts do not give grants to famous chefs and dressmakers, to pharmacologists, or even to surgeons, who have developed some of the highest skills of which humanity at present can boast. Popular usage is not a decisive measure of meanings, but to defy it does demand some special reason. Above all, I find the broad definition philosophically poor, because it raises no specific problems of art through which general ideas about art might be developed.

Art is craftsmanship, but to a special end: the creation of expressive forms—visually, audibly, or even imaginatively perceivable forms that set forth the nature of human feeling. This statement, I think, is simply true or false for all places and times; if it was false when the caveman painted their pictures—sacred, or magical, or just ostentatious, intended to simulate wealth, or whatever they were—if it was false then, it is false now. If those pictures did not achieve their stylization and beauty by being expressive of an apprehended feeling, then the theory is wrong, and no change in human affairs will make it right today.

But the intriguing thing about this basic concept of

art is that all the major problems of art show up in relation to it, not one by one, but in direct or remote connection with each other: the autonomy of the several arts and their very intricate relations to one another, which are much more than the possession of some common features or equivalent elements; the origins and significance of styles; historical continuity, tradition and revolt, motivation and conscious purpose and extraneous aims, self-expression, representation, abstraction, social influences, religious functions, changes of taste and all the problems of criticism, the old wrangle about rules of art, and the deprecation of "mere technique." There are more problems that arise systematically from these, but the ones I have named have already arisen at quite definite points, and are enough to make me dizzy, so let them suffice as examples.

The concept of art as the creation of expressive forms to present ideas of feeling (or of what is sometimes called "inner life," "subjective reality," "consciousness" —there are many designations for it) is a constant, but the making of those forms is so varied that few people realize how many factors in history and in any actual, chance setting bear on it. I think most of the differences of opinion about artistic aims, canons, and standards arise on the level of these variables, which are too often taken for constants. The chief variable factors are:

(1) The ideas artists want to express.
(2) The discovered devices of artistic creation.
(3) The opportunities offered by the physical and cultural environment.
(4) Public response.

The first factor is the most important. The range of its variability is enormous; I think the only restriction on it is that all artistic ideas are ideas of something felt, or rather: of life as felt, for they need not be ideas of feelings that have actually occurred. The import of art is *imaginable feeling and emotion*, imaginable subjective existence. It is something quite different from daydream, which is imagined experience eliciting real emotion, somewhat like, somewhat unlike the emotion that a similar experience in reality would produce. In dream and personal phantasy a feeling is evoked; in a work of art it is conceived, formulated, presented. It is the work of art as a whole that symbolizes an emotional process—anything, from the rhythmic feeling of thinking a complex but clear, brief thought, to the whole sense of life, love, selfhood, and recognition of death that is probably the largest scope of our feeling. The relation between feeling presented and understood, and feeling activated by beholding and understanding the image of inner life, is another interesting problem that arises from this basic concept of art, and cannot be pursued here. It is probably a highly complex affair.

The feelings that interest people have their limitations, their day and place, just as the things and facts and activities that interest them do. The emotional patterns we want to appreciate are primarily our own—not personally, but culturally. When our culture reaches out suddenly beyond its old bounds and makes contacts with other cultures we become interested in new possibilities of feeling. It takes a while, but there comes a point when the beauty of an exotic art becomes apparent to us; then

we have grasped the humanity of another culture, not only theoretically but imaginatively. The discovery of beauty in Negro art, Polynesian art, and Alaskan art marked such extensions of emotional insight in our own age.

Feeling to be expressed dictates what Élie Faure called "The Spirit of the Forms." But the life of art is more detailed and involved than this big movement of the Spirit. Sometimes quite fortuitous things enter in to give it a historic turn—not things that alter the pattern of feeling, like cultural decay, new religions, commercial expansion, crusades or other social events, but such things as the invention of oil pigments, the finding of Carrara marble, the construction of the pipe organ in the high vaulted church. The influence of available art materials may easily be over-emphasized; what is much more influential, I think, is the discovery of fundamental artistic devices.

The introduction of a major device gives rise to a tradition in art. A tradition is usually something longer-lived than a style; styles may come and go within its history. Styles, too, are relative to devices, for the variation and combination and handing-down of devices is so great a process that we meet it as basic technique, composition, choice of subject-matter, idiom, "form" in the narrow sense in which we classify epics, ballads, sonnets, etc., as "literary forms," and it may meet us as "influence." The most powerful devices give rise to what may be called the "great traditions" in the arts; metric composition of words is such a basic device, giving rise to a great tradition, in poetry. In the history of Indo-

European culture it is probably as old as liturgical speech and incantation. Representation in plastic art is another. Our own history of art is so full of it that it is practically taken for granted, and we have in the past been more aware of its variants, or styles, than of representation itself as a picture-making or statue-making device. But in certain parts of the world where plastic arts exist, representation of creatures or things is used very sparingly (e.g., in Maori art), if at all, and some of our own artists today find it dispensable.

To create perceivable expressive forms is a *principle of art;* but the use of any device, no matter how important, is a *principle of creation in art.* I think the belief that the concept of art changes from age to age rests on the fallacy of taking the most general principles of artistic technique operative in some particular period and culture as the principles of art itself. That is what Aristotle did in the *Poetics;* he had a fundamental and clear understanding of the principles on which Greek drama was constructed. He also could see some fairly obvious parallels between dramatic structure and epic structure; in the epic one can find all the special forms (lyric, pastoral, ode, etc.) incidentally. So he was content to accept those principles of construction—the relation of plot to characters and the relations, rhythmic or other, between action and diction, the familiar divisions of the action, the famous "unities," and all the major devices of building Greek tragedy—as the ultimate principles of poetry itself.

Looking for a moment to another art than poetry, the same situation confronts us in Heinrich Schenker's

analysis of the principles of music. The breaking up of tones, or sounds of definite pitch, into their constituent overtones that determine the natural stations through which a melody moves, and the contrapuntal development on this melodic scaffold, or *Urlinie*, that gives rise to harmonic progression, seemed to him the lowest terms to which the fabric of music could be analyzed. But it follows, of course, that there can be no music without definite pitch—without, as he says, "harmony, that belongs to nature, and melody, that belongs to art." The vaguely bounded glissando of Hawaiian song and the drums of Africa are to him not music.

What Schenker has actually discovered, however, are the basic devices that have begotten the great tradition of European music. These are not the principles of all music. Watusi drums, monotone voices, even conches and rams' horns can make music. But the construction of melodies in the framework of harmonically related tones is probably the most powerful principle of musical creation that has ever been found.

The apparent uncertainty as to what art is, or what some particular art really is, that arises from taking principles of construction for the defining function of art itself, can be illustrated in every domain. But let us return to poetry, where we can find examples enough of warring opinions.

Nothing could be further from Aristotle's conception of poetic creation than that which Poe proposed in his famous lecture, *The Poetic Principle*. "A poem," he said there, "deserves its title only inasmuch as it excites, by elevating the soul. The value of the poem is in the

ratio of this elevating excitement. But all excitements are, through a psychal necessity, transient. That degree of excitement which would entitle a poem to be so called at all, cannot be sustained throughout a composition of any great length. . . . This great work, in fact [his direct reference is to *Paradise Lost*], is to be regarded as poetical, only when . . . we view it merely as a series of minor poems. If . . . we read it . . . at a single sitting, the result is but a constant alternation of excitement and depression." He did not even hesitate, in fine, to say: "In regard to the 'Iliad,' we have, if not positive proof, at least very good reason, for believing it intended as a series of lyrics; but, granting the epic intention, I can say only that the work is based in an imperfect sense of art."

This is the most heroic operation I have ever seen performed on the world's masterpieces to fit them into the compass of a highly special theory. What Poe was expounding was, of course, at best a principle of lyric composition, involved wherever a poem is made to render a single emotional experience. It was in keeping with his own straight-channelled talents, perhaps, that he saw no other poetic aims. He had less historical excuse than Aristotle for regarding principles of creation, or construction, as principles of art. But then, he was a lesser man.

A third normative theory that comes naturally to mind, because, although later than Poe's essay, it represents one of the very norms Poe was attacking as spurious, is Matthew Arnold's poetics. Arnold has summed up in one line his conception of poetry, "as a criti-

cism of life under the conditions fixed for such a criticism by the laws of poetic truth and poetic beauty."* A criticism of life; that contrasts brusquely, indeed, with Poe's statement: "I would define, in brief, the Poetry of words as *The Rhythmical Creation of Beauty*. Its sole arbiter is Taste. With the Intellect or with the Conscience, it has only collateral relations. Unless incidentally, it has no concern whatever either with Duty or with Truth."

Here we seem to have three different notions of what poetry is, and three different standards for its evaluation. But when you read these authors, chosen more or less at random, a little more closely, you find that the idea of what poetry is has in each case been taken for granted, and is implicitly supposed to be known; and that, moreover, the knowledge of it is intuitive, so there is nothing more to say about it. Arnold, of all people, had no business to perpetrate a circular definition: yet he defines poetry as a criticism of life controlled by the laws of *poetic* truth and *poetic* beauty. What is "poetic" can only be directly felt. Aristotle remarks that Homer understood the laws of organic composition by instinct, and in fact excelled all other poets in the same way (1451 b); and elsewhere he says that the greatest thing in poetry is to be "a master of metaphor," which cannot be learned from others because it involves logical intuition (1459 a). As for Poe, he says explicitly that the perception of Beauty is a separate faculty, which he calls "Taste," and sometimes the "Poetic Sentiment," and describes as an immortal instinct, which has given the

* "The Study of Poetry," in *Essays in Criticism*.

world "all *that* which it . . . has ever been enabled at once to understand and to *feel* as poetic."

Here we are indeed on very slippery ground. The word "Taste" has done its share to make it precarious. The old adage, "*De gustibus non disputandum*," has firmly established the belief that beauty is simply what satisfies taste, and as beauty is artistic value, such value depends on taste, just as the value of coffee or candy does; and it certainly seems, on this basis, like pure snobbism to set up the taste of a few as more important than that of the many—that is, to make anything but the most popular taste the measure of good art.

But, rather than subscribe to what seems to me a patently false conclusion, I would abandon the metaphor of "taste." It gives artistic experience a false simplicity, and overemphasizes the pleasure-component that it has in common with gustatory sensations. So I shall speak of the perception of beauty; and once we stop relating beauty to an irrational taste, beauty is not indefinable.

Louis Arnaud Reid, in his *A Study in Aesthetics* (1931), said, "Beauty is just expressiveness." Upon the definition of art proposed at the beginning of this lengthening lecture—"Art is the creation of forms expressive of human feeling"—Reid's dictum comes almost like a scholium. And, moreover, it has the pragmatic virtues by which I advertise my own theory. It explains why the finding of beauty must be intuitive; all semantical insights are. Such finding is a perception of import, akin to that of meaning. Also, the conception of beauty as the expressiveness of a form explains why beauty may go unperceived where, none the less, it exists;

why maturity enables us to appreciate what was once too strange, or too unpleasant in some way, or perhaps too enigmatic, to elicit our response to it as an expressive form. And especially, it makes accessible to investigation the reasons why art, throughout the ages, has been charged with one office after another, didactic, religious, therapeutic, and what not, as often as it has been absolved of any and all such functions and set up on a pedestal (or an easel) all by itself.

What guides one's imagination in drawing or carving a line, establishing a proportion in the building of a chicken coop or the planning of a temple, or in using words to create the image of an event (which may be the occurrence of a thought, or a passionate utterance), is intuition. But a guiding sense is not in itself a *motive* for making an expressive form. The motive has usually been supplied by other interests. This brings us to the third great variable factor in the life of art: the opportunities offered to artists by the cultural and physical environment.

Probably by far the greater part of the world's art has been made upon some fortuitous occasion, that is, not with the conscious intention of creating a work of art, but with the intention of making or performing or articulating something otherwise important. People gifted with artistic intuition take any such occasion to create expressive form. Look at the intricate, strong, handsome compositions of Alaskan totem poles; their makers probably had no art theory at all, but to make the post look impressive, holy, and alive they used every principle of composition and animation that could serve the cause

of sculpture. Women making pots undoubtedly made them for the sake of domestic uses, but they shaped them in fine, voluminous curves for art's sake. They may often have decorated pots, fabrics, and furniture with magic symbols to keep spooks away, but in the hands of an artist such symbolic representations offer, above all, an occasion for design; and two pots bearing the same symbols, and made of the same clay, may be worlds apart in artistic value. Ritual has always been a natural and fertile source of art. Its first artistic product is the dance. Ecstatic people probably pranced before they danced; but the intuitive perception of expressive forms in that prancing invited composition, the making of dance. We know on venerable authority that the Greek drama rose when the sacred dances, embodying mythical motifs, gave it opportunity. The worship was in a spirit of pity for humanity and fear of divine powers; and Aristotle imputes to tragedy the prime office of inspiring pity and fear.

Throughout the ages, the practice of artistic creation has seized on whatever occasions life offered; and artistic excellence has usually been felt as an enhancement of whatever other excellence the constructed object had. That explains the difficulty critics have often encountered in sorting out the artistic from the non-artistic values. The beauty of a sculptured Virgin that seems to enhance her godly grace is hard to judge apart from that effect, which may even have been the clearest aim that the sculptor consciously entertained; and a portrait that seems to render the sitter's character as his friends know or remember it—which the painter may have consciously

made his business—is naturally thought to be beautiful on that account. But if it is beautiful, it is so because the painter managed to use this portrayal of character as a means of organizing subtler pictorial elements and creating a more vital plastic effect than he could have achieved by ignoring the telling details of the model's appearance.

In poetry, the confusion of artistic with propositional significance sometimes seems to be past all redemption. Poetry is made of language, and language is normally a means of imparting discursive ideas—information, advice, comments, directions, and whatever else. Also, the literal meaning of words and sentences plays a major part in making poetry out of language. Poetic criticism, more than any other, is torn between the judgment of artistic aims, means, and achievement, and the judgment of what *the poet* is "telling" the reader; between the evaluation of something created and something asserted. Matthew Arnold's "criticism of life" is such a discursive message. Perhaps he himself was misled by an unhappy phrase. Poetry does, indeed, *make life appear in certain ways*, but that is not commenting on it. Comment itself when used as a poetic element is not the poet's comment, but the imaginary speaker's who makes it in the poem. His name may be simply, "I"; but that again is part of the poetic creation.

Finally, let us not ignore the fact that much art is made without waiting for any occasion; that sometimes sheer imagination goes to work. I don't know what made Chaucer write his tales, or what purpose Dante set himself in writing the *Divine Comedy*, besides that of

making good poetry. The great opportunity for poetic art really came in a later age with the printed book and the popular practice of reading. Artists are generally opportunists, like everybody else in his own business, but artistic impulses can also be conscious, and motivate the work itself. The fact that they are often unconscious, however, and that artistic principles are recognized and used intuitively while the artist's discursive ideas are disporting themselves in quite other directions, seems to me to account for the fact that the best artists have often thought they were doing the oddest things.

The variable factors in art—which include all the principles of construction, and the possible ways of feeling that guide their use—are so many that they offer a practically unlimited field of study. Every place has its art, every time brings something forth that belongs to it alone, every artist changes the progress of art. But to recognize as constants the principles of art itself seems to me to make sense out of those differences, and open an indefinite number of problems to empirical or historical investigation that have often appeared an unrelated jumble of "isms"—a great collection of points of view, but all too often with nothing much in sight.

9

THE ART SYMBOL AND THE SYMBOL IN ART

(AN INFORMAL TALK AT THE AUSTIN RIGGS PSYCHIATRIC CENTRE, 1956)

THE problems of semantics and logic seem to fit into one frame, those of feeling into another. But somewhere, of course, mentality has arisen from more primitive vital processes. Somehow they belong into one and the same scientific frame. I am scouting the possibility that *rationality arises as an elaboration of feeling*.

Such a hypothesis leads one, of course, to the possible forms of feeling, and raises the problem of how they can be conceived and abstractly handled. Every theoretical construction requires a model. Especially if you want to get into elaborate structures you have to have a model—not an instance, but a symbolic form that can be manipulated, to convey, or perhaps to hold, your conceptions.

Language is the symbolic form of rational thought. It is more than that, but at least it can be fairly well pared down to abstract the elements of such thought and cognition. The structure of discourse expresses the forms of

124

rational cogitation; that is why we call such thinking "discursive."

But discursive symbols offer no apt model of primitive forms of feeling. There has been a radical change—a special organization—in the making of rationality, perhaps under the influence of very specialized perception, perhaps under some other controlling condition. To express the forms of what might be called "unlogicized" mental life (a term we owe to Professor Henry M. Sheffer of Harvard), or what is usually called the "life of feeling," requires a different symbolic form.

This form, I think, is characteristic of art and is, indeed, the essence and measure of art. If this be so, then a work of art is a symbolic form in another way than the one (or ones) usually conceded to it. We commonly think of a work of art as representing something, and of its symbolic function, therefore, as representation. But this is not what I mean; not even secret or disguised representation. Many works represent nothing whatever. A building, a pot, a tune is usually beautiful without intentionally representing anything; and its unintentional representation may be found in bad and ugly pieces too. But if it is beautiful it is expressive; what it expresses is not an idea of some other thing, but an idea of a feeling. Representational works, if they are good art, are so for the same reason as non-representational ones. They have more than one symbolic function—representation, perhaps after two kinds, and also artistic expression, which is presentation of ideas of feeling.

There are many difficulties connected with the thesis that a work of art is primarily an expression of feeling—

an "expression" in the logical sense, presenting the fabric of sensibility, emotion, and the strains of more concerted cerebration, for our impersonal cognition—that is, *in abstracto*. This sort of symbolization is the prime office of works of art, by virtue of which I call a work of art an *expressive form*.

In *Feeling and Form* I called it "the art symbol." This aroused a flood of criticism from two kinds of critics— those who misunderstood the alleged symbolic function and assimilated everything I wrote about it to some previous, familiar theory, either treating art as a genuine language or *symbolism*, or else confusing the art symbol with *the symbol in art* as known to iconologists or to modern psychologists; and, secondly, those critics who understood what I said but resented the use of the word "symbol" that differed from accepted usage in current semantical writings. Naturally the critics who understood what I said were the more influential ones; and their objections brought home the nature and extent of the difference between the function of a genuine symbol and a work of art. The difference is greater than I had realized before. Yet the function of what I called "the art symbol"—which is, in every case, the work of art as a whole, and purely as such—is more *like* a symbolic function than like anything else. A work of art is expressive in the way a proposition is expressive—as the formulation of an idea for conception. An idea may be well expressed or badly expressed. Similarly, in a work of art, feeling is well expressed or badly, and the work accordingly is good, or poor, or even bad—note that in the last case an artist would condemn it as *false*. The

"significance" of a work, by virtue of which some early twentieth-century writers called it "significant form," is what is expressed. Since, however, *signification* is not its semantic function—it is quite particularly *not* a signal —I prefer Professor Melvin Rader's phrase, which he proposed in a review of *Feeling and Form*: "expressive form." This, he said, would be a better term than "the art symbol." I have used it ever since. Similarly, Professor Ernest Nagel objected to calling that which it expresses its "meaning," since it is not "meaning" in any of the precise senses known to semanticists; since then I have spoken of the *import* of an expressive form. This is the more convenient as the work may have *meanings* besides.

As a work of art is an expressive form somewhat like a symbol, and has import which is something like meaning, so it makes a logical abstraction, but not in the familiar way of genuine symbols—perhaps, indeed, a pseudo-abstraction. The best way to understand all these pseudo-semantics is to consider what a work of art is and does, and then compare it with language, and its doings with what language (or any genuine symbolism) does.

The expressive form, or art symbol, is, as I said before, the work of art itself, as it meets the eye (let us, for simplicity's sake, stay in the realm of pictorial art). It is the visible form, the apparition created out of paint deployed on a ground. The paint and the ground themselves disappear. One does not see a picture as a piece of spotted canvas, any more than one sees a screen with shadows on it in a movie. Whether there be things and persons

in the picture or not, it presents volumes in a purely created space. These volumes define and organize the pictorial space which they are, in fact, creating; the purely visual space seems to be alive with their balanced or strained interactions. The lines that divide them (which may be physically drawn, or implied) create a rhythmic unity, for what they divide they also relate, to the point of complete integration. If a picture is successful it presents us with something quite properly, even though metaphorically, called "living form."

The word "form" connotes to many people the idea of a dead, empty shell, a senseless formality, lip-service, and sometimes an imposed rule to which actions, speeches, and works must *conform*. Many people think of form as a set of prescriptions when they speak of art forms, such as the sonata form or the rondo in music, the French ballade in poetry, etc. In all these uses the word "form" denotes something general, an abstracted concept that may be exemplified in various instances. This is a legitimate and widespread meaning of "form." But it is not the meaning Bell and Fry had in mind, and which I propose here. When they spoke of "significant form" (or, as now I would say, "expressive form") they meant a visible, individual form produced by the interaction of colors, lines, surfaces, lights and shadows, or whatever entered into a specific work. They used the word in the sense of something *formed*, as sometimes wonderful figures of soft color and melting contours are formed by clouds, or a spiral like a coiled spring is formed by the growth of a fern shoot; as a pot is formed out of clay, and a landscape out of paint spots.

It may be a solid material form like the pot, or an illusory object like Hamlet's cloudy weasel. But it is a form for perception.

A work of art is such an individual form given directly to perception. But it is a special kind of form, since it seems to be more than a visual phenomenon—seems, indeed, to have a sort of life, or be imbued with feeling, or somehow, without being a genuine practical object, yet present the beholder with more than an arrangement of sense data. It carries with it something that people have sometimes called a quality (Clive Bell called "significant form" a quality), sometimes an emotional content, or the emotional tone of the work, or simply its life. This is what I mean by *artistic import*. It is not one of the qualities to be distinguished in the work, though our perception of it has the immediacy of qualitative experience; artistic import is *expressed*, somewhat as meaning is expressed in a genuine symbol, yet not exactly so. The analogy is strong enough to make it legitimate, even though easily misleading, to call the work of art the art symbol.

The difference, however, between an art symbol and a genuine symbol are of great interest and importance, for they illuminate the relations that obtain between many kinds of symbols, or things that have been so called, and show up the many levels on which symbolic and pseudo-symbolic functions may lie. I think a study of artistic expressiveness shows up a need of a more adaptable, that is to say more general, definition of "symbol" than the one accepted in current semantics and analytical philosophy. But we had better defer this

problem to a later point. Let us, for the time being, call a *genuine symbol* whatever meets the strictest definition. Here is a definition offered by Ernest Nagel, in an article called "Symbolism and Science": "By a symbol I understand any occurrence (or type of occurrence), usually linguistic in status, which is taken to signify something else by way of tacit or explicit conventions or rules of language."

A word, say a familiar common noun, is a symbol of this sort. I would say that it conveys a concept, and refers to, or denotes, whatever exemplifies that concept. The word "man" conveys what we call the concept of "man," and denotes any being that exemplifies the concept—i.e., any man.

Now, words—our most familiar and useful symbols —are habitually used not in isolation, but in complex concepts of states of affairs, rather than isolated things, and refer to facts or possibilities or even impossibilities: those bigger units are descriptions and statements and other forms of *discourse*.

In discourse, another function of symbols comes into play, that is present but not very evident in the use of words simply to name things. This further function is the expression of ideas *about* things. A thing cannot be asserted by a name, only mentioned. As soon as you make an assertion you are symbolizing some sort of relation between concepts of things, or maybe things and properties, such as: "The grapes are sour." "All men are born equal." "I hate logic." Assertions, of course, need not be true—that is, they need not refer us to facts.

That brings us to the second great office of symbols,

which is not to refer to things and communicate facts, but to express ideas; and this, in turn, involves a deeper psychological process, the formulation of ideas, or conception itself. Conception—giving form and connection, clarity and proportion to our impressions, memories, and objects of judgment—is the beginning of all rationality. Conception itself contains the elementary principles of knowledge: that an object of thought keeps its identity (as Aristotle put it, "A = A"), that it may stand in many relations to other things, that alternative possibilities exclude each other, and one decision entails another. Conception is the first requirement for thought.

This basic intellectual process of conceiving things in connection belongs, I think, to the same deep level of the mind as symbolization itself. That is the level where imagination is born. Animal intelligence or response to signs, of course, goes further back than that. The process of symbolic presentation is the beginning of human mentality, "mind" in a strict sense. Perhaps that beginning occurs at the stage of neural development where speech originates, and with speech the supreme talent of *envisagement*.

Response to stimuli, adaptation to conditions may occur without any envisagement of anything. Thought arises only where ideas have taken shape, and actual or possible conditions imagined. The word "imagined" contains the key to a new world: the image. I think the popular notion of an image as a replica of a sense impression has made epistemologists generally miss the most important character of images, which is that they are symbolic. That is why, in point of sensuous character,

they may be almost indescribably vague, fleeting, fragmentary, or distorted; they may be sensuously altogether unlike what they represent. We think of mathematical relations in images that are just arbitrarily posited symbols; but these symbols are our mathematical images. They may be visual or auditory or what not, but functionally they are images, that articulate the logical relations we contemplate by means of them.

The great importance of reference and communication by means of symbols has led semanticists to regard these uses as the defining properties of symbols—that is, to think of a symbol as essentially a sign which stands for something else and is used to represent that thing in discourse. This preoccupation has led them to neglect, or even miss entirely, the more primitive function of symbols, which is to formulate experience as something imaginable in the first place—to fix entities, and formulate facts and the fact-like elements of thought called "fantasies." This function is *articulation*. Symbols articulate ideas. Even such arbitrarily assigned symbols as mere names serve this purpose, for whatever is named becomes an entity in thought. Its unitary symbol automatically carves it out as a unit in the world pattern.

Now let us return to the Art Symbol. I said before that it is a symbol in a somewhat special sense, because it performs some symbolic functions, but not all; especially, it does not stand for something else, nor refer to anything that exists apart from it. According to the usual definition of "symbol," a work of art should not be classed as a symbol at all. But that usual definition overlooks the greatest intellectual value and, I think, the prime

office of symbols—their power of formulating experience, and presenting it objectively for contemplation, logical intuition, recognition, understanding. That is articulation, or logical expression. And this function every good work of art does perform. It formulates the appearance of feeling, of subjective experience, the character of so-called "inner life," which discourse—the normal use of words—is peculiarly unable to articulate, and which therefore we can only refer to in a general and quite superficial way. The actual felt process of life, the tensions interwoven and shifting from moment to moment, the flowing and slowing, the drive and directedness of desires, and above all the rhythmic continuity of our selfhood, defies the expressive power of discursive symbolism. The myriad forms of subjectivity, the infinitely complex sense of life, cannot be rendered linguistically, that is, stated. But they are precisely what comes to light in a good work of art (not necessarily a "masterpiece"; there are thousands of works that are good art without being exalted achievements). A work of art is an expressive form, and vitality, in all its manifestations from sheer sensibility to the most elaborate phases of awareness and emotion, is what it may express.

But what is meant by saying it does not connote a concept or denote its instances? What I mean is that a genuine symbol, such as a word, is only a sign; in appreciating its meaning our interest reaches beyond it to the concept. The word is just an instrument. Its meaning lies elsewhere, and once we have grasped its connotation or identified something as its denotation we do not need the word any more. But a work of art does

not point us to a meaning beyond its own presence. What is expressed cannot be grasped apart from the sensuous or poetic form that expresses it. In a work of art we have the direct presentation of a feeling, not a sign that points to it. That is why "significant form" is a misleading and confusing term: an Art Symbol does not signify, but only articulate and present its emotive content; hence the peculiar impression one always gets that feeling is in a beautiful and integral form. The work seems to be imbued with the emotion or mood or other vital experience that it expresses. That is why I call it an "expressive form," and call that which it formulates for us not its meaning, but its *import*. The import of art is perceived as something in the work, articulated by it but not further abstracted; as the import of a myth or a true metaphor does not exist apart from its imaginative expression.

The work as a whole is the image of feeling, which may be called the Art Symbol. It is a single organic composition, which means that its elements are not independent constituents, expressive, in their own right, of various emotional ingredients, as words are constituents of discourse, and have meanings in their own right, which go to compose the total meaning of the discourse. Language is a *symbolism*, a system of symbols with definable though fairly elastic meanings, and rules of combination whereby larger units—phrases, sentences, whole speeches—may be compounded, expressing similarly built-up ideas, Art, contrariwise, is not a symbolism. The elements in a work are always newly created with the total image, and although it is possible to

analyze what they contribute to the image, it is not possible to assign them any of its import apart from the whole. That is characteristic of organic form. The import of a work of art is its "life," which, like actual life, is an indivisible phenomenon. Who could say how much of a natural organism's life is in the lungs, how much in the legs, or how much more life would be added to us if we were given a lively tail to wave? The Art Symbol is a single symbol, and its import is not compounded of partial symbolic values. It is, I think, what Cecil Day Lewis means by "the poetic image," and what some painters, valiantly battling against popular misconceptions, call "the absolute image." It is the objective form of life-feeling in terms of space, or musical passage, or other fictive and plastic medium.

At last we come to the issue proposed in the title of this lecture. If the Art Symbol is a single, indivisible symbol, and its import is never compounded of contributive cargoes of import, what shall we make of the fact that many artists incorporate symbols in their works? Is it a mistake to interpret certain elements in poems or pictures, novels or dances, as symbols? Are the symbolists, imagists, surrealists, and the countless religious painters and poets before them all mistaken—everybody out of step except Johnnie?

Symbols certainly do occur in art, and in many, if not most, cases contribute notably to the work that incorporates them. Some artists work with a veritable riot of symbols; from the familiar halo of sacrosanct personages to the terrible figures of the *Guernica*, from the obvious rose of womanhood or the lily of chastity to the personal

symbols of T. S. Eliot, sometimes concentric as a nest of tables, painters and poets have used symbols. Iconography is a fetrile field of research; and where no influence-hunting historian has found any symbols, the literary critics find Bloom a symbol of Moses, and the more psychological critics find Moses a symbol of birth.

They may all be right. One age revels in the use of symbolism in pictures, drama, and dance, another all but dispenses with it; but the fact that symbols and even whole systems of symbols (like the gesture-symbolism in Hindu dances) may occur in works of art is certainly patent.

All such elements, however, are genuine symbols; they have meanings, and the meanings may be stated. Symbols in art connote holiness, or sin, or rebirth, womanhood, love, tyranny, and so forth. These meanings enter into the work of art as elements, creating and articulating its organic form, just as its subject-matter—fruit in a platter, horses on a beach, a slaughtered ox, or a weeping Magdalen—enter into its construction. Symbols used in art lie on a different semantic level from the work that contains them. Their meanings are not part of its import, but elements in the form that has import, the expressive form. The meanings of incorporated symbols may lend richness, intensity, repetition or reflection or a transcendent unrealism, perhaps an entirely new balance to the work itself. But they function in the normal manner of symbols: they mean something beyond what they present in themselves. It makes sense to ask what a Hound of Heaven or brown sea-girls or Yeat's Byzantium may stand for, though in a poem where symbols are perfectly

used it is usually unnecessary. Whether the interpretation has to be carried out or is skipped in reception of the total poetic image depends largely on the reader. The important point for us is that there is a literal meaning (sometimes more than one) connoted by the symbol that occurs in art.

The use of symbols in art is, in fine, a principle of construction—a device, in the most general sense of that word, "device." But there is a difference, often missed by theorists, between principles of construction and principles of art. The principles of art are few: the creation of what might be termed "an apparition" (this term would bear much discussion, but we have no time for it, and I think any one conversant with the arts knows what I mean), the achievement of organic unity or "livingness," the articulation of feeling. These principles of art are wholly exemplified in every work that merits the name of "art" at all, even though it be not great or in the current sense "original" (the anonymous works of ancient potters, for instance, were rarely original designs). Principles of construction, on the other hand, are very many; the most important have furnished our basic devices, and given rise to the Great Traditions of art. Representation in painting, diatonic harmony in music, metrical versification in poetry are examples of such major devices of composition. They are exemplified in thousands of works; yet they are not indispensable. Painting can eschew representation, music can be atonal, poetry can be poetry without any metrical scaffold.

The excited recognition and exploitation of a new constructive device—usually in protest against the tradi-

tional devices that have been used to a point of exhaustion, or even the point of corruption—is an artistic revolution. Art in our own day is full of revolutionary principles. Symbols, crowding metaphorical images, indirect subject-matter, dream elements instead of sights or events of waking life, often the one presented through the other, have furnished us lately with a new treasure-trove of motifs that command their own treatments, and the result is a new dawning day in art. The whole old way of seeing and hearing and word-thinking is sloughed off as the possibilities inherent in the modern devices of creation and expression unfold. In that excitement it is natural for the young—the young spirits, I mean, who are not necessarily the people of military or marriageable age—to feel that they are the generation that has discovered, at last, the principles of art, and that heretofore art labored under an incubus, the false principles they repudiate, so there never really was a pure and perfectable art before. They are mistaken, of course; but what of it? So were their predecessors—the Italian Camerata, the English Lake Poets, the early Renaissance painters—who discovered new principles of artistic organization and thought they had discovered how to paint, or how to make real music, or genuine poetry, for the first time. It is we, who philosophize about art and seek to understand its mission, that must keep distinctions clear.

In summary, then, it may be said that the difference between the Art Symbol and the symbol used in art is a difference not only of function but of kind. Symbols occuring in art are symbols in the usual sense, though

of all degrees of complexity, from simplest directness to extreme indirectness, from singleness to deep inter-penetration, from perfect lucidity to the densest over-determination. They have meanings, in the full sense that any semanticist would accept. And those meanings, as well as the images that convey them, enter into the work of art as elements in its composition. They serve to create the work, the expressive form.

The art symbol, on the other hand, *is* the expressive form. It is not a symbol in the full familiar sense, for it does not convey something beyond itself. Therefore it cannot strictly be said to have a meaning; what it does have is import. It is a symbol in a special and derivative sense, because it does not fulfill all the functions of a true symbol: it formulates and objectifies experience for direct intellectual perception, or intuition, but it does not abstract a concept for discursive thought. Its import is seen in it; not, like the meaning of a genuine symbol, by means of it but separable from the sign. The symbol in art is a metaphor, an image with overt or covert literal signification; the art symbol is the absolute image—the image of what otherwise would be irrational, as it is literally ineffable: direct awareness, emotion, vitality, personal identity—life lived and felt, the matrix of mentality.

10

POETIC CREATION

Poetry is universally regarded as one of the "fine arts,"
like music, painting, sculpture, architecture, and dance.
It is an art of words. On that proposition I think all
authorities agree.

In a sense, of course, all speech is an "art of words";
"art" in the sense in which we sometimes say of anything
difficult that "it's an art," or even "it's a fine art." But
that is not what people mean when they class poetry
among the fine arts. They mean expressly to set the
poetic use of language apart from its use in ordinary
discourse; and in this attempt they often get deeper and
deeper into the toils of semantics, psychology, and aes-
thetics. Fact and feeling, seeing and saying get mixed
up in every conceivable combination, and yet no *princi-
pium divisionis* emerges to distinguish the poetic function
of words from any or all the rest. To find the source
of this failure and a way of deciding between poetry
and other products of language is my purpose tonight.

Ever since Locke, and to some extent Bacon and

Hobbes before him, distinguished the strictly conceptual use of language in mathematics, logic, and physics from its emotional use in religious or political harangue, and noted the mixture of both functions in ordinary social intercourse, language has been regarded under these two aspects. Books have been written, courses given, and institutes founded on the fundamental distinction between the informative and the evocative use of words. The former is regarded as the proper, literal use that results in meaningful statements, or genuine propositions; the latter as self-expressive, communicating the speaker's feelings to other people who react either sympathetically or antipathetically. We are told that such utterances, though they sound like statements, really assert nothing; but these pseudo-propositions which have no scientific meaning are said to be, nevertheless, highly important instruments of social control.

This doctrine, which Bertrand Russell expounded some forty years ago, it still in vogue. In the simplified form to which popular presentation has reduced it, it is obvious enough to command general assent, and it contains enough truth to throw light on some rather bizarre phenomena, such as the ardor of other people's patently false beliefs, the effectiveness of sheer oratory in politics and in advertising, the strange social fact that people manage to talk together quite happily in sentences that cannot bear even the slightest degree of logical analysis. It is, indeed, a theory that lends itself admirably to popularization, and has become the main stock in trade of amateur philosophers today.

But its wide acceptance is bought at a price. When

professional semanticists concentrate their efforts on finding ever simpler and more graphic ways of presenting and defending a theory, they stop working on the theory itself. They tend to ignore its difficulties beyond those which a general public would perceive and question. The danger of simplification is that it shelves the more abstruse problems and creates the appearance that they could easily be resolved if one wanted to expand one's exposition. The theory of the emotive use of language, for instance, employs the concept of self-expression, i.e., completion of the motor arc by speech, the concept of suggestion, or natural effect of self-expressive behavior, and the concept of communication, or deliberate imparting of value judgments leading to explicit agreement or disagreement. Self-expression, suggestion, and communication of value judgments are all "emotive uses of language," but each in a different way; and the interesting question of their involvements with each other are obscured by lumping all these uses together in simple contrast to the scientific use, the literal statement of facts (or supposed facts). Even if a speaker or writer says "Of course, this is a simplification," he is likely to stick to the simplified version of semantic problems himself, and take for granted that other possible uses of language are subsidiary to one or the other of his two kinds.

An important illustration of this danger is the effect which the popularized simplified semantic doctrine has had on the philosophical treatment of poetry even by our leading scholars. Since language is used in poetry, but literal scientific statement is clearly not its intended use,

it is uncritically assumed that the poet must be making the other use of his words, namely the evocative. He must be registering his emotional reactions to the subject of his poem, trying to make us have similar reactions, and/or pronouncing value judgments in non-literal pseudo-propositions. So we read, in current poetics and criticism, that the poet takes us into his confidence, that he tells us things between the lines, enlists our sympathy for his feelings, and imparts his ultimate religious, moral, and metaphysical judgments "through the language of the heart," that is to say, through the evocative use of words.

In reading such semantical studies of poetry one may be left wondering why poetic language is so often referred to as "creative," and its product as "poetic creation." What is created? If the reader's feelings are stirred up, and he is led to take various attitudes toward life, what is created, in a strict sense? The feelings? They are only stimulated, as they are by ordinary social communication. The facts of life? They are talked about, not made; they were there before. To call such suggestion and commentary "creation" sounds a bit pretentious, like referring to all works of art as "masterpieces."

Before we try to answer the major question I have just put before you—"What is created in poetry?"—it might be helpful to consider the nature of artistic creation in general, in other arts.

In a painting, the essential creation is the appearance of a space, which is not the space wherein the picture hangs and the spectator stands. The wall that supports the painting is not *in* the painting; it is not part of the

picture space. The spectator is not in the picture space. that space which is the painter's creation is really new. The paints and the canvas, the materials of his work, were in the studio before, and have simply been moved about by his efforts. But the space we see as a result of that new development was not there before. It is a created apparition.

All created factors in a work of art are *elements* of it. Its elements are what we discover when, casually or carefully, we analyze it. Background and foreground, high lights, empty air, motion, accent, intensity of color, depth of darkness, objects in relation to each other—all these are elements. Canvas and paints, the actual light that falls on the picture, are materials. They are used, not created.

Music, like painting, is a purely created form not of space, but of time; its materials are tones of varying pitch, loudness, and quality, but its elements are tonal forms, moving, mingling, resolving, having direction and energy, violently active or abating toward complete rest. Its time, as well as all the great and small tonal forms (melodies, progressions) that make it up, are appearances made of sound; music is time made audible and articulated as a perceptible, dynamic form. Every art, indeed, creates a special sort of appearance, in terms of which all its works are made.

So much, then, for the meaning of "creation" in art generally. Now let us return to the question of poetry. What does a poet create? Poetry is made of words; but words are the poet's heritage, and not something he creates. They are materials which he uses. The poem,

the work of art, somehow results from the way he uses them.

He seems to use them much as he would in writing a letter or speaking, to make statements, ask questions, or register his reactions to things by exclaiming over them. A poem is usually in the form of a discourse about something, just like a conversation or a report, and exhibits all the familiar structures we call "sentences" of various kinds. So, first of all, the poet seems to be *saying things*.

Now, it is universally recognized, I think, that *what the poet says* could also be said in somewhat different words—that is, that his statements could be quite faithfully repeated in paraphrase—but that the poetic composition would almost certainly be lost in such a retelling. A person making a poem evidently uses words not only to say things, but to say them in certain ways. And speculation has run high, for decades if not centuries, as to the parts played by the sound and sense of the words, the images they convey, the feelings they evoke. Meter and rhyme are certainly products of their sound, that have functioned traditionally in poetry. Imagery is a natural by-product of their sense. The total result is much more than a literal statement; it is a statement that makes the stated fact appear in a special light.

Everyone knows that the way an idea is expressed may serve to recommend it to people or to make it seem horrible. The selfsame fact wears two very different faces in the American and the Soviet press, respectively. It all depends on the way it is put. This obvious power of words to give the content of discourse

almost any desired appearance is exploited today both by political and commercial interests; it is the essence of propaganda and of advertising; both build on the fact that people will respond to a statement with enthusiasm, anger, indifference, or other emotion, according to the way it is worded.

In view of our preoccupation, in the present phase of history, with such emotional responses, it is perhaps inevitable that literary theorists should regard poetry, too, as an appeal to the reader's emotions, to enlist his sympathy for the poet's feeling about the world, the emptiness of life, the ugliness of war, the absurdity of everything, or whatever the poem presents. Poetry is quite generally regarded as a communication, not of facts, but of the values the poet puts upon facts which, simply as facts, are probably as well known to us as to him: the facts of living and dying, loving and loathing, playing the hypocrite, soldiering, worshipping, having children. The facts he mentions constitute *what he says;* the values are given to them by *the way he says it.* His aim, so we are told, is to make us share his particular way of experiencing these familiar events and conditions of the world.

If, now, we ask again my persistent question: what does a poet create? the critics to whom I refer can readily answer: the *appearance* that is given to the subject matter by his words. And in this I agree with them. What any artist—poet, painter, dancer, musician or what not—creates, is always an appearance. The appearance created in poetry is effected by the way words are handled. But beyond this I cannot go with them,

namely, to the conclusion that the poet, like the orator or advertiser, is lending that created appearance to things in the actual world, about which he is talking to us. The entire problem of how and what a poet communicates to his reader seems to me a specious one, arising from the commonsense assumptions that if he writes declarative sentences he must be making statements, and *pari passu*, if he writes interrogative ones he must be asking questions, and if we are his readers he must be addressing them to us. These assumptions, though made by common sense, are wrong, and prevent us from treating poetry in the same way as all the other arts.

Under the aegis of scientific method, social science, and popular semantics, we have missed a trick, I think, in the philosophy of language. Most of our interest in language has been prompted by needs and problems of communication. Consequently communication by words has been the key concept of our studies of language; in fact, some semanticists regard language as originally and properly a signaling device, elaborated to an amazing degree—even to the point where the code suffers confusions, because its signs figure in too many connections at once and become overcharged with meanings, so that failure of communication or mixed deliveries result. That accounts, they believe, for the fact that most of the time language does not look like the conventional set of signals it is supposed to be.

The use of language for poetic creation has received no more than honorable mention in our schools; usually it is simply lumped with one or all of the familiar emotive functions. The reason is, I think, that we are

so dominated by interest in communication, and the poetic use of words is not essentially communicative. Language is the material of poetry, but what is done with this material is not what we do with language in actual life; for *poetry is not a kind of discourse at all*. What the poet creates out of words is an *appearance* of events, persons, emotional reactions, experiences, places, conditions of life; these created things are the elements of poetry; they constitute what Cecil Day Lewis has called "the poetic image." A poem is, in precisely his sense, an image. This image is not necessarily visual; since the word "image" has an almost irresistible connotation of visualness, I prefer to call the poetic image a *semblance*. The created poetic semblance need not be a semblance of corresponding actual things, facts, persons, or experiences. It is quite normally a pure appearance, a sheer figment; it is essentially a virtual object; and such a virtual object is a work of art. It is entirely created. Its material is language, its motif, or model, usually discursive speech, but what is created is not actual discourse—what is created is a composed and shaped apparition of a new human experience.

The composed apparition has as definite a structure as a musical composition, a piece of sculpture, an architectural work, or a painting. It is not a report or comment, but a constructed form; if it is a good poetic work it is an *expressive form* in the same way that a work of plastic art is an expressive form—by virtue of the tensions and resolutions, balances and asymmetries among its own elements, which beget the illusion of organic nature that artists call "living form."

The general problem of expressive form, which I believe is the central problem of aesthetics, is not our subject today; but we cannot evade it entirely, since we are dealing with one of its special cases, the creation of a sheer appearance, or virtual event, by means of words. This is a use of words quite distinct from their usually recognized uses; it may be called the *formulative* function of language, which has its own primitive and advanced, unconscious and conscious levels. It is normally coincident with the communicative functions, but largely independent of them; and while its most spectacular exhibition is in poetry, it is profoundly, though not obviously, operative in our whole language-bound mental life. In autistic speech it is the paramount purpose. Communication is less likely to stimulate it than to set its limits, and hold spontaneous ways of shaping experience to something like a standard pattern. In this way, it is the communicative office of language that makes the actual world's appearance public, and reasonably fixed. The formulative power of words is the source and support of our imagination; before there can be more than animal communication, there has to be envisagement, and a means of developing perception in keeping with conception. Beings who have speech almost certainly have quite a different sort of direct experience of the world from creatures that use only self-expressive or directive signs.

The greatness of the gulf between speechless and speech-molded life has been contemplated and stressed particularly by the philosophers who trace their intellectual descent from Kant, and accept, howbeit with

various reservations, the Hegelian concept of "*Geist*"—that is, the concept of the human mind as a creative entity not belonging to physical nature but to a different order of reality. Their metaphysical assumptions, however, are not necessary to every theory of mind that would recognize the role of conception in perception, memory, and feeling, and the role of language in conception. There are historical and psychological reasons why all non-idealistic philosophers have either missed or deliberately slighted the problem of verbal imagination, even to the point of side-stepping the whole phenomenon. But the involvements of language with all the rest of human mentality are really as amenable to naturalistic treatment as to an idealistic approach.

For the philosophical understanding of poetry and its relation to art in general, the current positivistic credo of "general semantics" is simply inadequate; a more intimate study of the functions of language is required than their customary divisions into propositional uses (sub-divided into various modes) and emotional uses (with sub-divisions casually suggested). The greatest work to date that has been done on the subject has come from another quarter, and may be found in Ernst Cassirer's *Philosophy of Symbolic Forms;* but there are scattered, more recent sources, chiefly in the fields of anthropology, linguistics, and poetics, for instance Whorff's studies of the Hopi language, from which only the most superficial and obvious conclusions have yet been drawn.

More promising, however, than the semantical approach to poetry is the approach from poetry to

semantics. Poetry exhibits, like nothing else in the world, the formulative use of language; it is the paradigm of creative speech. For the poetic use of language is essentially formulative. Poetry is not a beautified discourse, a particularly effective way of telling things, although poetic structures may occur in discourse with truly artistic effect. Poetry as such is not discourse at all, it is the creation of a perceptible human experience which, from the standpoint of science and practical life, is illusory. It may create an apparition reminiscent of actual events and places, like a historical or locally oriented novel, or it may be a free invention of places, events, actions, and persons; but such different compositions are not different kinds of art. All poetry is pure poetry, though it be only more or less successful; it is primarily and not incidentally creative. In poetic composition one may see the formulative use of language deliberately and consciously pursued and the result spectacularly isolated. We are far more likely to learn the poetical function of words by studying poetry, and recognize it subsequently in more obscure contexts, such as dream psychology or history of language, than we are to find it in those contexts first and build a theory that can be made to fit poetry too.

The assumption that the poetic use of language is essentially formulative, and per se not communicative, has some interesting consequences. The most important is that, if propositions are not poetic elements, but materials out of which the elements of a poem are fashioned, then poetry may be regarded and treated as an art in exactly the same way as painting or music: as the crea-

tion of a self-contained, pure appearance, a perceptible expressive form. Such a conception of poetry frees us from the embarrassment of having to consider under different rubrics what, on the one hand, the poet is saying—that is, the sense and truth-value of his statements—and on the other hand the skill with which he says it; and of always having to strike a nice balance between those two interests. Poetic statements are no more actual statements than the peaches visible in a still life are actual dessert. The real question is what the poet *makes*, and that, of course, depends on how he goes about it. The task of poetic criticism, then, is not to learn from any and all available records what was the poet's philosophy, morality, life history, or psychosis, and to find the revelation of his own experiences in his words; it is to evaluate his fiction, the appearance of thought and feeling or outward events that he creates.

A poem that rises to great heights does so by virtue of the way it is built up—built out of words, but not therefore just a pattern of words. Consider Keats's sonnet, "When I have fears that I may cease to be"; it certainly reaches a poetic peak in the lines:

> When I behold, upon the night's starr'd face,
> Huge cloudy symbols of a high romance,
> And think that I may never live to trace
> Their shadows, with the magic hand of chance

This rise, however, is not due to any burst of self-expression, nor reference to persons or events in Keats's life; it is due to a sudden concentrated appearance of knowledge and mystery, vastness and transience, effected by rather few words, sonorous and rhythmically

slow. There is not even a visual image; for the clouds cannot be taken as clouds casting shadows. They are his immaterial visions and their images. Clouds against the night sky cast no outlined shadows; the figure is not a simple metaphor—it is poetically natural but not borrowed from nature. It contains a factual distortion, much like spatial distortion in paintings. What it creates is a moment of intense awareness of many feelings, paradoxical yet confluent. That moment would be great and important to the reader even if he did not know that Keats actually died young and was probably aware of his short lease of life. It is not by sympathy with Keats that one is moved, but by the poetic composition, which would be exactly as moving if it were anonymous.

To read poetry as a psychological document, in a context of the author's life, putting in further meanings and personal allusions from circumstantial knowledge, is to do violence to the poem. That is forcibly making statements out of its lines, and expanding their meaning far beyond anything that serves the poetic figment. The result is sometimes fatal to the poem, making it sound false or silly, as *Ash Wednesday* did to Edmund Wilson, when he wrote: "I am made a little tired at hearing Eliot, only in his early forties, present himself as an 'agéd eagle' who asks why he should make the effort to stretch his wings."

The reaction shows, I think, the banefulness of the common assumption that a poem becomes more significant to the reader if he can read it in a context of the author's reconstructed life, and picture to himself the conditions under which the poem was written. All such

supplements are really destructive of a composition. They have no creative function whatever, and clutter the work with inorganic added stuff. Where a reference to some place or person serves an artistic purpose the poet is, after all, free to put it in, perhaps in the title, perhaps directly in the work: "Composed on Westminister Bridge," or:

When it's yesterday in Oregon it's one A.M. in Maine,

or:

Mock on, mock on, Rousseau, Voltaire!

Many a time, however, names do not really relate a poem to an actual setting. The use of specific names is often just as effective where these denote nothing known to the reader—like the place names in our translations of Chinese poetry—as where they refer to known places and persons, like Grantchester, Dublin, Bonaparte, Dante. That depends on the use the poet makes of them. Often his main intent is simply to create the semblance of individual reference, so he chooses proper names primarily for their sound and only in a general way for their connotation; or his first consideration may be to make the reference specific but strange, so he tosses unfamiliar words about, just making sure they will be taken as proper names:

Where the ninth wave flows in Perython,
Is the grave of Glwalchmai, the peerless one;
In Llanbadarn lies Clydno's son.

There would be nothing added to our perception and understanding of that poem by identifying the Welsh

heroes and places whose names are woven into it, and uncovering their biographies. All they need to do for us is to sound Welsh and fill a cherished land with historic graves. For the Wales in the poem is a creation, constituted exactly as the poet presents it, and having no political, economic, or other aspects, to tie it up with British elections or American tourist agencies.

Some odd revaluations of poetic work may result if one shifts from the traditional question: "What is the poet telling us, and how does he communicate his experiences?"—to: "What has the poet created, and how did he do it?" Many strange turns, that serve neither to communicate ideas nor to express sentiments about the world or anything in it, are suddenly seen in an important role: they are constructing the "poetic image" itself, the poem as a virtual experience, which is neither the poet's nor ours, but exists for his and our imaginative perception. Consider, for instance, a poem we probably all have read, in school or in one of the famous anthologies—Browning's little song from *Pippa Passes:*

> The year's at the spring
> And day's at the morn;
> Morning's at seven;
> The hill-side's dew-pearl'd;
> The lark's on the wing;
> The snail's on the thorn;
> God's in His heaven—
> All's right with the world!

My English teacher in High School praised that poem as a fine expression of Browning's optimism. I thought his view of the world was very silly, for a man with a

big beard. Oh, but Browning believed in progress, and he believed in God, and the key line to the whole poem was "God's in His heaven"!

Teacher explained that the song occurred in a play about two people who had lost all faith, and at the crucial moment heard Pippa's song outside the window, reassuring them. I thought it might take a little more than a young thing's opinion to reassure them. Pippa's view of life seemed even less important than Browning's. And even if that utterance made sense in a play, why was the poem in the Oxford Book and everywhere else? I hated it.

Many years later I read it in its context, in the dramatic poem, *Pippa Passes*. It comes like a sudden distant call. It turns the action. And the key line *is*, "God's in His heaven"! Then I looked at it poetically, to see what made it *feel* the way it did.

An odd structure: each short line a complete statement, and in the first three lines the same colloquial turn of phrase, shifted from one colorless assertion to another until, in the third occurrence, it sounds artificial; then, the first image. The pattern of the verses is insistently schematic: three lines saying something is "at" something, then a statement of condition; three more lines saying something is "on" or "in" something, and another statement of condition, this time entirely general, universal. What does it sound like?—A roll call for "all aboard." This man is here, that man is there—one at this, one at that—the side is clear; each on his post, *the captain up there in his place*—she's trim!

It is this structure of the roll call, taken from its normal

156

maritime setting and transposed to the countryside, the loud masculine "aye-aye, sir!" transmuted into a girl's song, the fierce sea images into gentle dewy slopes, that makes the perfect abstraction of feeling—the readiness, the eagerness of a launching. Not a mention, not a metaphor of the ship appears; only the same sense of beginning, launching the young day.

The little poem can bear quite persistent study. Every symbol is right, every bone of its structure covered. That is composition. And in this composition the final idea that is stated loses its philosophical weight: the whole image is only of the day. There is no optimistic belief expressed at all.

If we look at poetry as a created form, we find in every successful poem some unfamiliar devices, and have to beware of looking for the traditional ones before we are quite sure of what is in the works. An eminent critic has taken Swinburne to task for failing to develop his images even to the point of letting the reader grasp them before they pass. The poem that elicited this censure was the first chorus from *Atlanta in Calydon*. All its rich imagery, the critic claimed, is lost because the liquid flow of the words fairly drives one to read fast, and causes each image to pass before it is really formed, and to be crowded out by another that meets the same fate. And surely he is right; the lines fairly race, if you speak them in the most natural, unrhetorical way:

When the hounds of springs are on winter's traces,
The mother of months in meadow or plain
Fills the shadows and windy places
With lisp of leaves and ripple of rain;

And the brown bright nightingale amorous
Is half assuaged for Itylus,
For the Thracian ships and the foreign faces,
The tongueless vigil, and all the pain.

Come, with bows bent and with emptying of quivers,
Maiden most perfect, lady of light,
With a noise of winds and many rivers,
With a clamor of waters, and with might;
Bind on thy sandals, O thou most fleet,
Over the splendor and speed of thy feet;
For the faint east quickens, the wan west shivers,
Round the feet of the day and the feet of the night.

Where shall we find her, how shall we sing to her,
Fold our hands round her knees, and cling?
O that man's heart were as fire and could spring to her,
Fire, or the strength of the streams that spring!
For the stars and the winds are unto her
As raiment, as songs of the harp-player;
For the risen stars and the fallen cling to her,
And the southwest-wind and the west-wind sing.

For winter's rains and ruins are over,
And all the season of snows and sins;
The day's dividing lover and lover,
The light that loses, the night that wins;
And time remembered is grief forgotten,
And frosts are slain and flowers begotten,
And in green underwood and cover
Blossom by blossom, the spring begins.

If it was the poet's intention to describe the events
in nature that constitute the coming of spring, make us
realize them in imagination and share his way of seeing
each one, then certainly they pass too swiftly, and never

develop as sensuous experiences. But is a picture of spring the essential creation, the expressive form itself, or do his references to grass and flowers and rain and birdsong serve a different semblance? What is the motif?

The poem does not create a sensuous image, but a dynamic one—a vision of the emotional drive sometimes called "Spring Fever." That drive is from within; what elicits it is the totality of things, their separate qualities are irrelevant. Swinburne's intent, therefore, is to crowd and pile impressions so they blur each other, and to drive ideas with ideas, each emotionally toned, even quite highly strung, but none a fixed object of any emotion. The result is an unearthly excitement, not distilled from the poetic image of spring, but absorbing all the images into itself.

Statement, allusion, imagery, grammatical form, word rhythm, and any other elements in a poem all have essentially and purely creative functions. Even obscurity, which always goads critics into paraphrasing the problematical lines, is a poetic element; sometimes the reader is not supposed to find a line clear, any more than he is supposed to see an outline of the forms of chiaroscuro painting. Something is created by the difficulty of diction, the sense of incomprehensibility. Sometimes coherence of ideas is not needed; then it is left out. There is coherence of another sort, as in De la Mare's *Peacock Pie*—coherence of form or mood. Confession of feeling or opinion, made in the first person, is no more discourse than a self-portrait is the painter. Real confession would belong to another order. Poetry generates its own entire world, as painting generates its entire continuum of

space. The relation of poetry to the world of facts is the same as that of painting to the world of objects: actual events, if they enter its orbit at all, are *motifs* of poetry, as actual objects are motifs of painting. No matter how faithful the image, it is a pure image, unmixed with bits of actuality. It is a created appearance, an expressive form, and there is properly nothing in it that does not enhance its symbolic expression of vitality, emotion, and consciousness. Poetry, like all art, is abstract and meaningful; it is organic and rhythmic, like music, and imaginal, like painting. It springs from the power of language to formulate the appearance of reality, a power fundamentally different from the communicative function, however involved with it in the evolution of speech. The pure product of the formulative use of language is verbal creation, composition, art; not statement, but *poesis*.

APPENDIX

ABSTRACTION IN SCIENCE AND ABSTRACTION IN ART

(Reprinted from *Structure, Method and Meaning: Essays in Honor of Henry M. Sheffer,* by permission of The Liberal Arts Press, Inc.)

ALL genuine art is abstract. The schematized shapes usually called "abstractions" in painting and sculpture present a very striking technical device for achieving artistic abstraction, but the result is neither more nor less abstract than any successful work in the "great tradition," or for that matter in Egyptian, Peruvian, or Chinese art—that is, in any tradition whatever.

Yet the abstractness of a work of art seems to be something quite different from that of science, mathematics, or logic. This difference lies not in the meaning of "abstraction," as offhand one might suppose; we are not dealing with a mere ambiguity. Both in art and in logic (which carries scientific abstraction to its highest development), "abstraction" is the recognition of a relational structure, or *form,* apart from the specific thing (or event, fact, image, etc.) in which it is exemplified. The difference lies in the way the recognition is achieved

in art and science, respectively; for abstraction is normally performed for some intellectual purpose, and its purpose differs radically from the one context to the other. The two characteristic processes of abstracting a form from its concrete embodiment or exemplification go back, therefore, as far as the fundamental distinction between art and science itself; and that is a long way back.

There seem, indeed, to be two meanings of the word "form" involved in the two fields, respectively. A logician, mathematician, or careful epistemologist may question what sense it makes to call anything "form" except the logical form of discourse, the structure of propositions expressed either in ordinary language or in the refined symbolism of the rational sciences. Wherever terms exist at all for him they can be named; the relations among them can be named (although their "names" may be indirect, may be parentheses or even mere positions in a line of print); and no matter how complex their combinations may be, those terms and relations are wholly expressible in verbal or algorithmic propositions. Why, then, call anything "form" that is not capable of such presentation?

Yet artists do speak of "form" and know what they mean; and, moreover, their meaning is closer than that of the logicians to what the word originally meant, namely, "visible and tangible shape." The artists, therefore, may ask in their turn how one can speak of the "form" of something invisible and intangible—for instance, the series of natural numbers, or an elaborate mathematical expression equal to zero. Their sense of

the word has undergone refinements, too, in plastic art, it does not mean that at all. The forms achieved by prose fiction are neither shapes nor logical systems; for although literary works contain propositions, literary form is not the systematic unity of a complex literal statement. The artistic form is a perceptual unity of something seen, heard, or imagined—that is, the configuration, or *Gestalt*, of an experience. One may say that to call such an immediately perceived *Gestalt* "form" is merely a metaphor; but it would be exactly as reasonable to say that the use of the word for syntactical structures is metaphorical, derived from geometry, and carried over into algebra, logic, and even grammar.

If one cannot tell which of the two meanings is literal and which is figurative, it is fairly safe to assume that both make use of a single underlying principle which is exemplified in two different modes. The basic principle of "form" determines that close relation between apperceptive unity and logical distinctions which was known to the ancients as "unity in diversity." But they might just as well have called it "diversity in unity"; for it is sometimes thought to relate many individually conceived things or properties each to each, directly or indirectly, producing a whole, and sometimes to distinguish many elements from one another where an all-inclusive unit is the first assumption. The preposition "in" is an unfortunate word to designate the construction of a coherent system out of given factors; but when it serves *also* to designate the articulation of structural elements of a given whole, it is as bad a hyperbole for the

expression of relational concepts as ever bedeviled classical philosophy.

Yet the two ideas—constructed unity and organic differentiation of an original whole—both involve the more general concept of *relative distinctness*. They are specifications of this concept that arise from epistemological sources, from the nature of logical intuition and the nature of the symbols whereby we elicit and promote it. Now the object of logical intuition is *form;* and although there are two ways of developing our perception of this object, and consequently two sets of associations with the word "form," the use of it is equally and similarly justified in both contexts.

There are certain relational factors in experience which are either intuitively recognized or not at all, for example, distinctness, similarity, congruence, relevance. These are formal characteristics which are protological in that they "must be seen to be appreciated." One cannot take them on faith. The recognition of them is what I mean by "logical intuition." All discourse is a device for concatenating intuitions, getting from one to another, and building up the greater intuitive apperception of a total *Gestalt*, or ideal whole.

Artistic intuition is a similar protological experience, but its normal progress is different. It begins with the perception of a total *Gestalt* and proceeds to distinctions of ideal elements within it. Therefore its symbolism is a physical or imaginal whole whereof the details are articulated, rather than a vocabulary of symbols that may be combined to present a coherent structure. That is why artistic form is properly called "organic" and

discursive form "systematic," and also why discursive symbolism is appropriate to science and artistic symbolism to the conception and expression of vital experience, or what is commonly termed "the life of feeling."

As art and discursive reason differ in their starting points of logical intuition, so they differ in all their intellectual processes. This makes the problem of abstraction appear entirely different in the two domains. Yet artists and logicians are equally concerned with abstraction, or the recognition of pure form, which is necessary to any understanding of relationships; and they perform it with equal spontaneity and carry it, perhaps, to equally great lengths of skillful manipulation.

There is a widespread belief—sometimes regarded as a very truism—that abstract thought is essentially artificial and difficult, and that all untutored or "natural" thought is bound to concrete experiences, in fact to physical things. But if abstraction were really unnatural, no one could have invented it. If the untutored mind could not perform it, how did we ever learn it? We can develop by training only what is incipiently given by nature. Somewhere in man's primitive repertoire there must have been a spontaneous intellectual practice from which the cultivated variety of abstract thought took its rise.[1]

This instinctive mental activity is the process of symbol-making, of which the most amazing result is language. All symbolization rests on a recognition of congruent forms, from the simple one-to-one corre-

[1] This fact was noted by T. Ribot in an article, "Abstraction Prior to Speech," in *The Open Court* (1899), Vol. XIII, pp. 14-20.

spondence of name and thing that is the dream of speech reformers[2] to the most sophisticated projection of thought into conventional systems of notation. The logic of symbolic expression is an old story though not completely told even yet; it is still gaining precision in works like C. I. Lewis' *Analysis of Knowledge and Valuation*. But its main outlines are familiar enough to need no restatement here. The interesting thing in the present context is that the growth of language takes place at all times in several dimensions, and each of these entails a primitive and spontaneous form of abstractive thinking. The appreciation of pure conceptual forms as such is indeed a late and difficult attainment of civilized thought, but the abstraction of formal elements for other intellectual purposes is a natural and even an irrepressible human activity. It permeates all thought and imagination —reason, free association, play, delirium, and dream. And although I am convinced that some abstractions cannot be made verbally at all, but can be made by the non-discursive forms we call "works of art,"[3] yet the basic abstractive processes are all exemplified in language at various stages of its ever-productive career. Some transcend its limitations soon, and others late; some leave it and become completely articulate only in the various

[2] Cf. Bertrand Russell's *Philosophy* (New York, 1927), Ch. IV; and his later and more elaborate *Inquiry into Meaning and Truth* (New York, 1940), especially the first four chapters; also G. B. Shaw's Preface to R. A. Wilson's *The Miraculous Birth of Language* (New York, 1948).

[3] Here I regret to disagree radically with Professor Lewis, who says: "It is doubtful that there are, or could be, meanings which it is intrinsically impossible for words to express."—*An Analysis of Knowledge and Valuation* (La Salle, Ill., 1946), p. 73.

media of art; some remain essentially linguistic and simply transform and develop language in their natural advance, giving it more and more of what we call "literal meaning," more and more precise grammar, and finally the algorithmic extensions that belong rather to written language than to speech.

We have no record of any really archaic tongue; the origins of all known languages lie beyond the reaches of history. But as far back as we can go, language has two essential functions, which may be called, somewhat broadly, "connotation" and "denotation" (the exact distinctions made by Professor Lewis[4] are indeed relevant here), but I resort to the less precise, traditional terms because, in the small compass of this essay, the roughest characterization that will serve the purpose is the most economical). Connotation belongs to all symbols; it is the symbolic function that corresponds to the psychological act of conception. Denotation accrues to symbols in practical use, for the applicability of concepts to "reality" is, after all, their constant pragmatic measure. Both conception and denotation through language are natural activities, instinctive, popular, and therefore freely improvisational and elaborative; and both involve a constant practice of abstraction from the pure experience of *this, here-and-now*.

The principles of abstraction that govern the making of symbolic expressions vary, however, with the purposes (conscious or unconscious) to which those expressions are to be put. One outstanding purpose is, certainly, to attain *generality* in thought. The tremen-

[4] *Ibid.*, Ch. III.

dous practical value of language lies largely in its power of generalization, whereby the naming of any object immediately establishes the class of *such* objects. This is a very rudimentary abstractive function inherent in language as such, as Ribot observed more than fifty years ago,[5] and as Cassirer has demonstrated in *The Philosophy of Symbolic Forms*.[6] The earliest class-concepts, therefore, are directly linked with the assignment of names to objects.

The modern empiricists, notably Locke, took it for granted that the "simple qualities"—such as colors, tones, smells and tastes, pressures—were the items most directly presented to the mind through primitive, unguided sense experience, and therefore remembered—that is, conceived—even as meaningless "data." Oddly enough, the development of language, which mirrors the history of those twin functions, perception and conception, gives a different view of elementary qualities. Judging by early nomenclature, we find that colors, for instance, were not always distinguished by their actual spectrum values—that is, as "red," "blue," "yellow," and so forth —but primarily as warm or cold, clear or dull. Walde's comparative etymological dictionary[7] renders the meaning of the Indo-European root *ĝhel* as "*glänzen, schimmern, gelb, grün, grau oder blau.*" The names for definite pigments were late established, and often changed their signification completely from one hue to another. Thus the current word "blue," German *blau*, derives from

[5] In the essay previously alluded to.
[6] See especially Vol. I, Chs. IV and V.
[7] Walde, *Vergleichendes Wörterbuch der indogermanischen Sprachen* (Leipzig, 1926).

blavus, a Middle Latin form of *flavus*, meaning, not "blue," but "yellow."[8] *Black* is descended from *bhleg*, and cognate with *blanc*, *blank*, Swedish *black*, Norwegian *blakk*, meaning "white." The oldest sense is probably preserved in "bleak." But what is even more surprising is that the connotation of an adjective often shifts entirely from one sensory field to another. The German word *hell*, now applied literally only to light and color—that is, to visual impressions—and sometimes used metaphorically of tones, seems originally to have referred to sounds first and foremost, and to have come into use for visual effects only around the time of Martin Luther. In fact, when Luther employs it to describe light, he always says "*hell licht*," "*am hellen lichten Tag*," and the old meaning is still preserved in the idiom "*ein heller Haufe*," which refers not to a bright throng but a noisy one.

Yet the apparently capricious changes of meaning, often from the original quality to its very opposite, follow a perfectly obvious principle: a word designates any quality that can symbolize a certain feeling. This seems to be the law of that metaphorical extension whereby whole groups of words arise out of one phonetic "root," all embodying this root in their sound and deriving their meaning from its archaic sense, which Max Müller aptly called the "root metaphor." The original reference of adjectives especially appears to have been primarily to feeling tones, and hence, quite freely and naturally, to any sense-qualities that helped the conception of them. Therefore extreme opposites of sensa-

[8] *Ibid.*

tion were often designated by the same word: white and black, hot and cold,[9] high and deep (Latin *altus*). Both extremes of a sensation symbolize the same intensity of feeling. The true opposite of their value is a low-keyed sensation—dim, gray; lukewarm; flat, shallow. Primitive thought is fairly indifferent to the particular order of sensation from which the qualitative symbol is taken, so long as it conveys the subjective value of the experience to be recorded.

But language is not only an intellectual tool whereby concepts are formed; it is also a common currency for the exchange of them; and this public interest puts a premium on objective reference and develops the function of denotation. The attachment of verbal labels to *things* is the major purpose of words in social use. Every device that facilitates naming is naturally accepted and exploited; and perhaps the greatest of such devices is generalization, the treatment of every actually given thing as a representative of its *kind*—that is, of every "this" as a "such-as-this." The establishment of kinds, or classes of things, requires some easily recognizable mark of membership in otherwise diverse objects, and this interest was probably what led people from the conception of qualities through feeling-tones to the more precise observation of publicly comparable features—the hues, shapes, sizes, noises, temperatures, and the rest that modern languages honor with adjectives: blue, round, big, loud, cold, and so forth. With this fixation of characters, the old contrast between "extreme" and "middling" would be broken down by the

[9] Walde gives the meanings of the root *kel* as: "(1) frieren, kalt. (2) warm."

discovery that there are two different "extremes"; and their close association, amounting even to fusion in a single root-metaphor, would lead to a new, powerful, abstracted notion—the notion of a *dimension*, a range or gamut of experiences. Then the qualities within one dimension could be distinguished, named, comparatively treated; the principles of empirical analysis supervene over the earlier recognition of feeling-tones; and language become the mighty instrument of discursive thought in which Aristotle found the laws of logic reflected.

The "simple qualities" of empiricism, the "data" that are obviously distinct for us, are so by virtue of language; and their classification in sensory orders—such as hues, sounds, tastes, and so on—is already a long step toward science. This step is effected by the spontaneous processes of symbolic transformation that give rise to language in the first place: metaphor, which always involves a basic recognition of the common form that justifies the substitution of one image for another; and the principle of *pars pro toto*, exemplifying the class-concept involved. But these primitive insights into formal conditions do not constitute "abstraction" in a strict sense. They are abstractive processes implicit in symbol-making and symbol-using, rather than a recognition of abstracted elements as such. Genuine abstraction is a relatively late achievement, born of reflection on the works of art and science, and fully understood only by means of the latter. But once we attain the concept of abstract form, or pure structure apart from the things in which it is exemplified, we find that both art and science constantly tend toward the maximum revelation of abstract

elements, and both for the same purpose—namely, to create more and more powerful symbols—but by different procedures, born of their different intuitive starting points.

The driving principle of science is generalization. Its subject matter is really something perfectly concrete—namely, the physical world; its aim is to make statements of utmost generality about the world. And generalization, as we have just seen, arises from the denotative character of language, from the fact that a named thing is at once a focus of "reality"—that is, a fixed entity—and a symbol for its kind; since a name is always a class label as well as a handle for its specific object. (Even supposedly individual, or proper, names tend to serve in this double capacity: "*A Daniel* come to judgment!") The principle of classification, inherent in language, begets the logic of quantified statement that underlies the development of scientific thought. There was good reason why a logic guided by scientific aims should have been developed in extension rather than intension; the extension of a term is the range of its denotation, and denotation is its link with the world, the object of science. Bertrand Russell, in one of his brilliant early essays, called this extensionalism "the Principle of Abstraction . . . which might equally well be called the principle that dispenses with abstraction."[10] Actually, it does not dispense with them at all, but moves over them without explicit recognition, because its aim is to put all abstracted forms to further use—much as we do in making our unconscious abstractions by the common-sense use

[10] *Our Knowledge of the External World*, 2nd ed. (New York, 1929), p. 44.

of language—and to make general statements about reality—that is, assert general facts of nature.

It was only with the development of mathematics that abstract logical forms became so apparent and, in their appearance, so interesting that some logicians turned their attention to the study of *form as such* and undertook the abstraction of relational patterns from any and every concrete exemplification. Russell, despite his proposal to dispense with abstractions, was one of the first advocates of that new logic and (together with Whitehead) one of its great promoters; for, oddly enough, systematic generalization—the principle that was to obviate the need of abstraction—furnished exactly the technique whereby structures were brought to light, symbolically expressed and recognized as pure abstract forms. Russell's leanings toward physical science are so strong that perhaps he does not see the entire potential range of philosophical studies built on the study of relational logic. Whitehead came nearer to it; Peirce and Royce saw it;[11] but the actual development of systematic abstraction to the point where it can be an eye-opener to philosophers has been the special task of the man to whom these essays are dedicated. In natural science, generalization is all we require, and mathematics is valued for its power of general statement and complex manipulations without any loss of generality. But in pure mathematics the element of logical form is so commandingly evident that mathematical studies naturally lead to a theory of structure as such and to a systematic study of abstraction.

[11] C. S. Peirce, "The Architecture of Ideas," in *Chance, Love and Logic;* Josiah Royce, "The Principles of Logic," especially Sec. III, in *Encyclopedia of the Philosophical Sciences,* edited by Windelband and Ruge, Eng. transl. (1913).

That study is logic, and its technique is progressive generalization. The use of generalization to make abstract structure apparent was more or less accidental until Sheffer saw its possibilities and built a pure logic of forms upon it. This work gave logic a different aim, not only from the old traditional "art and science of inference," but even from the modern development of truth-value systems; for instead of being essentially a scientific tool, logic thus becomes an extension of human interest beyond the generalized empirical thought of science, to the domain of abstract form, where the very principles of symbolism, conception, and expression lie open to inquiry and technical demonstration.

If we now turn to the domain of the arts, it seems as though nothing comparable to logical abstractness could be found there at all, but everything were immediate, unintellectual, and concrete. Yet a little conversance with any art quickly reveals its abstract character. A work of art is a symbol; and the artist's task is, from beginning to end, the making of the symbol. And symbol-making requires abstraction, the more so where the symbolic function is not conventionally assigned, but the presented form is significant simply by virtue of its articulate character. The meanings of a work of art have to be imaginatively grasped through the forms it presents to the sense or senses to which it is addressed; and, to do this, the work must make a forceful abstraction of "significant form" from the concrete stuff that is its medium.

But the abstractive process of art is entirely different from that of science, mathematics, and logic; just as the

forms abstracted in art are not those of rational discourse, which serve us to symbolize public "fact," but complex forms capable of symbolizing the dynamics of subjective experience, the pattern of vitality, sentience, feeling, and emotion. Such forms cannot be revealed by means of progressive generalization; this makes the whole development of art and all its techniques radically different from those of discursive thought. Although art and science spring from the same root, namely, the impulse to symbolic expression—of which the richest, strongest, and undoubtedly oldest manifestation is language—they separate practically from the beginning.[12]

A work of art is and remains specific. It is "this," and not "this kind"; unique instead of exemplary. A physical copy of it belongs to the class of its copies, but the original is not itself a member of this class to which it furnishes the class concept. We may, of course, classify it in numberless ways, for example, according to its theme, from which it may take its name—"Madonna and Child," "Last Supper," and so on. And as many artists as wish may use the same theme, or one artist may use it many times; there may be many "Raphael Madonnas" and many "Last Suppers" in the Louvre. But such class-membership has nothing to do with the artistic importance of a work (the classification of a scientific object, on the other hand, always affects its scientific importance).

The artist's problem, then, is to treat a specific object abstractly; to make it clearly an instance of a form, with-

[12] For a full discussion of this point, see E. Cassirer, *The Philosophy of Symbolic Forms*, especially Vol. I, ch. I.

out resorting to a class of similar objects from which the form underlying their similarity could be abstracted by the logical method of progressive generalization. The first step is usually to make the object *un*important from any other standpoint than that of appearance. Illusion, fiction, all elements of unreality in art serve this purpose. The work has to be uncoupled from all realistic connections and its appearance made self-sufficient in such a way that one's interest does not tend to go beyond it. At the same time, this purely apparent entity is simplified so that the ear, eye, or (in the case of literary art) the constructive imagination can take in the whole pattern all the time, and every detail be seen in a fundamental, unfailing context—*seen related*, not seen and then rationally related. Whether there is much detail or little, what there is must seem an articulation of the total semblance. In the case of a piece that is not physically perceivable at one time, as for instance a novel, a long drama or opera, or a series of frescoes constituting a single work, the proportion of the whole has to be established at all times by implication, which is a special and technical problem. In any event, the perception of a work of art as "significant form"—significant of the nature of human feeling —always proceeds from the total form to its subordinate features.

This manner of perception, which the work is designed to elicit, causes it to appear *organic;* for the evolution of detail out of an indivisible, self-sufficient whole is characteristic of organisms and is the material counterpart of their function, life. And so the work of art seems to have organic structure and rhythms of life, though it is patently not a real organism but a lifeless object. If

the semblance is forcible enough—that is, if the artist is successful—the impression of living form becomes commanding and the physical status of the piece insignificant. The form of organic process which characterizes all vital function has been abstracted, and the abstraction made directly from one specific phenomenon, without the aid of several examples from which a general pattern emerges that may then be symbolically rendered. In art, the one instance is intelligibly constructed and is given the character of a symbol by suppression of its actual constitution as painted cloth, vibrating air, or (somewhat less simply) a string of the conventional counters called "words," whose relative values are recorded in the dictionary. When its proper material status is cancelled by the illusion of organic structure, its phenomenal character becomes paramount; the specific object is made to reveal its logical form.

Yet it does not present an abstracted concept for our contemplation; the abstractive process is only an incident in the whole function of a work of art, which is to symbolize subjective experience—that is, to formulate and convey ideas of sentience and emotion. The abstracted form of organic relations and vital rhythms is only an ingredient in the total expression of feeling, and remains implicit in that greater process. But it is the framework; and, once it is established, the whole realm of sense-perception furnishes symbolic material. Here the inherent emotive significance of sense-data comes into play. The natural relationship between sensory qualities and feelings, which governs the extension of language by the development of "root-metaphors," also determines the function of sensuous materials in art.

Surfaces, colors, textures and lights and shadows, tones of every pitch and quality, vowels and consonants, swift or heavy motions—all things that exhibit definite qualities—are potential symbols of feeling, and out of these the illusion of organic structure is made. That is why art is essentially qualitative and at the same time abstract. But the sensuous elements, often spoken of as the "sense-content" of a work, are not content at all but pure symbol; and the whole phenomenon is an expanded metaphor of feeling, invented and recognized by the same intuition that makes language grow from the "root-metaphors" of fundamentally emotive significance.

Artistic abstraction, being incidental to a symbolic process that aims at the expression and knowledge of something quite concrete—the facts of human feeling, which are just as concrete as physical occurrences—does not furnish elements of genuine abstract thought. The abstractive processes in art would probably always remain unconscious if we did not know from discursive logic what abstraction is. They are intuitive, and often most successful and complete in primitive art. It is through science that we recognize the existence of pure form, for here it is slowly achieved by conscious method and finally becomes an end in itself for the entirely unempirical discipline of logic. That is probably why so many people stoutly maintain that art is concrete and science abstract. What they should properly say—and perhaps really mean—is that science is general and art specific. For science moves from general denotation to precise abstraction; art, from precise abstraction to vital connotation, without the aid of generality.

INDEX